America THE Beautiful
WASHINGTON, DC

JORDAN WOREK

Photographs by RANDY SANTOS

FIREFLY BOOKS

A FIREFLY BOOK

Published by Firefly Books Ltd. 2010

Third printing, 2015

Publisher Cataloging-in-Publication Data (U.S.)

Worek, Jordan.
 Washington, DC / Jordan Worek ; Randy Santos.
[] p. : col. photos. ; cm. America the Beautiful series.
Summary: Captioned photographs showcase the remarkable architecture,
dynamic neighborhoods and exciting attractions of Washington, D.C.
ISBN-13: 978-1-55407-593-5
1. Washington (D.C.) - Pictorial works. 2. Washington (D.C.) - Buildings,
structures, etc. - Pictorial works. I. Santos, Randy. II. America the
Beautiful / Dan Liebman. III. Title.
975.3 dc22 F195.W67 2010

Published in the United States by
Firefly Books (U.S.) Inc.
P.O. Box 1338, Ellicott Station
Buffalo, New York 14205

Published in Canada by
Firefly Books Ltd.
50 Staples Ave., Unit 1
Richmond Hill, Ontario L4B 0A7

Cover and interior design: Kimberley Young

Printed in China

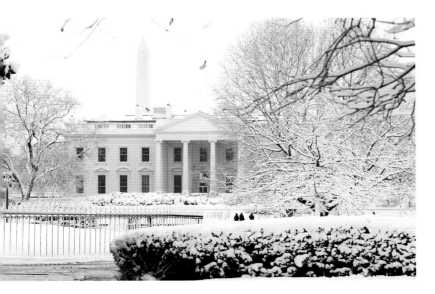

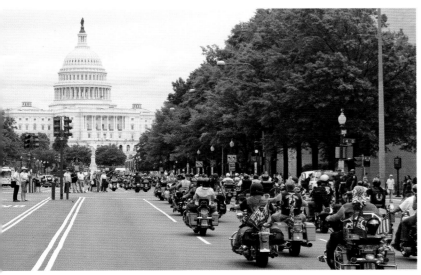

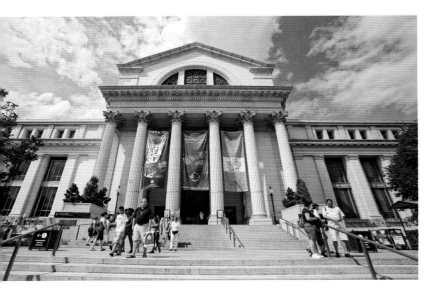

Washington, DC, is packed with history. It is a city of monuments and memorials, iconic buildings, architectural landmarks and outstanding museums. It is also the capital of the United States and a symbol of what Americans hold dear. But Washington is more than that: it is a living capital with vibrant neighborhoods, picturesque streetscapes and outstanding attractions – and a city where history continues to be created.

In 1785, Congress voted to build a permanent federal city, and the location along the Potomac River was selected as a compromise between the northern and southern states. George Washington enlisted Pierre Charles L'Enfant to design the capital. The architect's plan called for the large ceremonial spaces and grand tree-lined avenues that define the city today.

In the pages of *America the Beautiful – Washington, DC,* familiar sights are stunningly photographed alongside lesser-known places.

There is, of course, the White House – "a house owned by all the American people" – as well as the Capitol, the Washington Monument, and the Lincoln and Jefferson Memorials. There are poignant scenes, too, including the eternal flame at JFK's gravesite as well as *The Three Soldiers* sculpture and the Vietnam Women's Memorial.

Other places include the Smithsonian National Museum of American History and the International Spy Museum, which is dedicated to the art and adventure of espionage

Also captured are locations popular with locals and visitors looking to escape the city, among them the rolling Appalachian Mountains that run through Western Maryland as well as Mount Vernon, George Washington's home located just south of the capital in Virginia.

And there are cherry blossoms, the embassy district, the Watergate complex, Rolling Thunder motorcyclists converging on the Mall, the streets of historic Georgetown – and much more.

Washington, DC, is the center of power, politics and democracy. As you travel the pages of the book, we hope you'll experience a city that is beautiful for many things: architecture, institutions, natural settings and, especially, ideals.

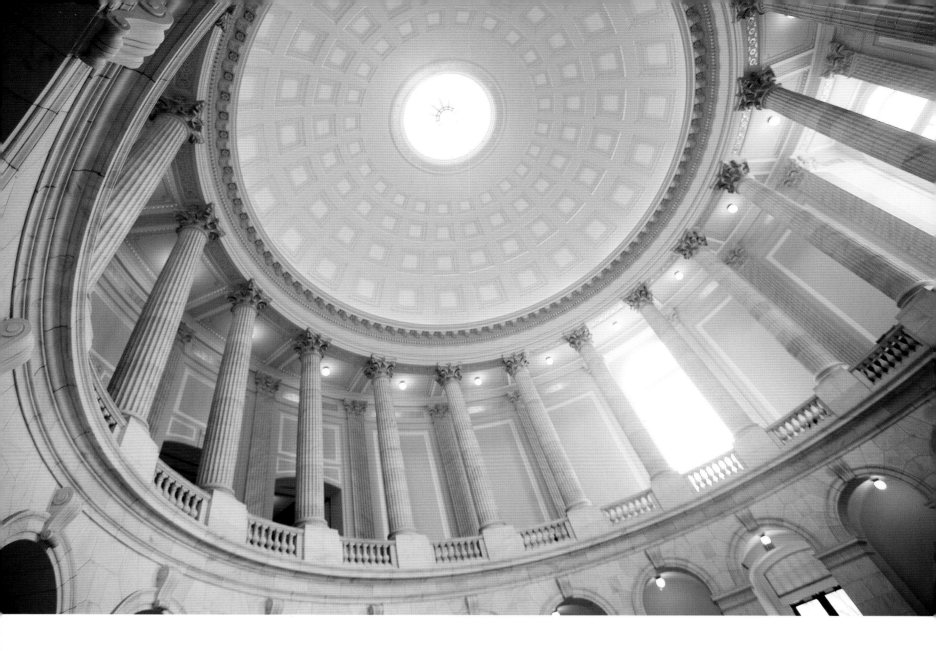

Completed in 1908, the Cannon House Office Building is the oldest Congressional office in Washington and a stunning example of the Beaux Arts architectural style. Eighteen Corinthian columns support the rotunda seen here.

OPPOSITE PAGE: Opened in 2004, the National Museum of the American Indian is a strikingly handsome structure whose undulating sand-colored limestone walls distinguish it from the rest of the buildings along the Mall. Thousands of objects and many exhibits showcase the culture and history of the American Indian.

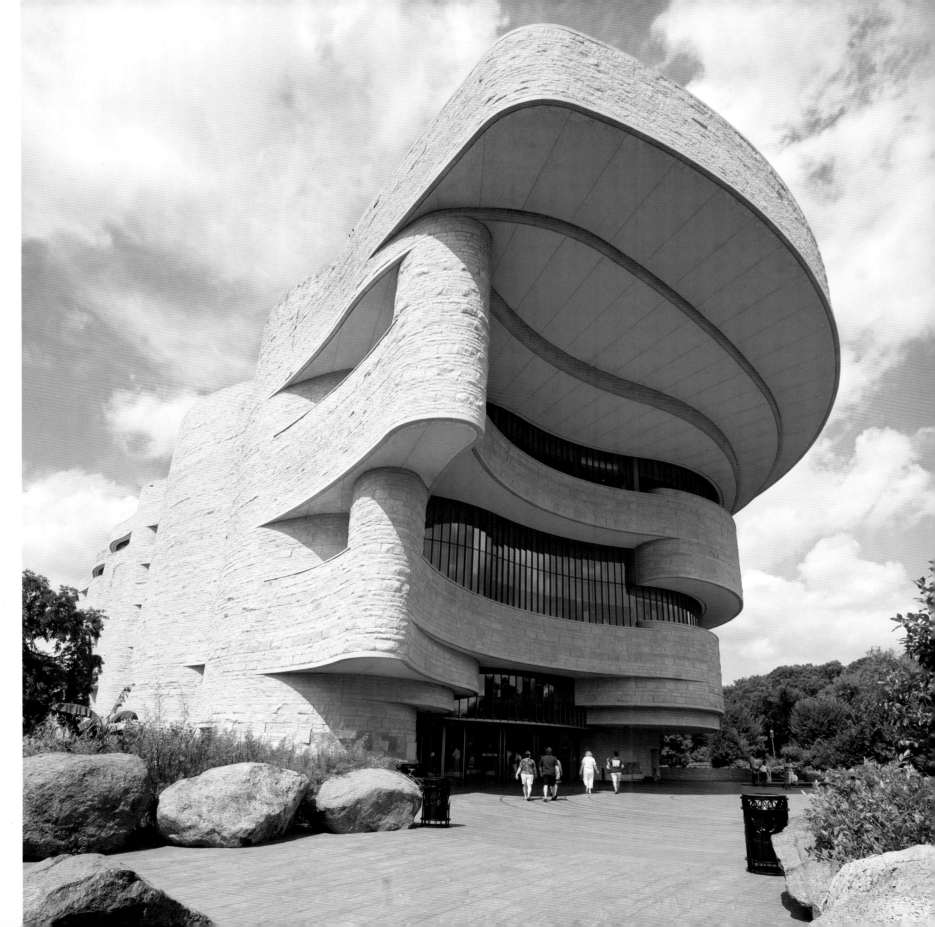

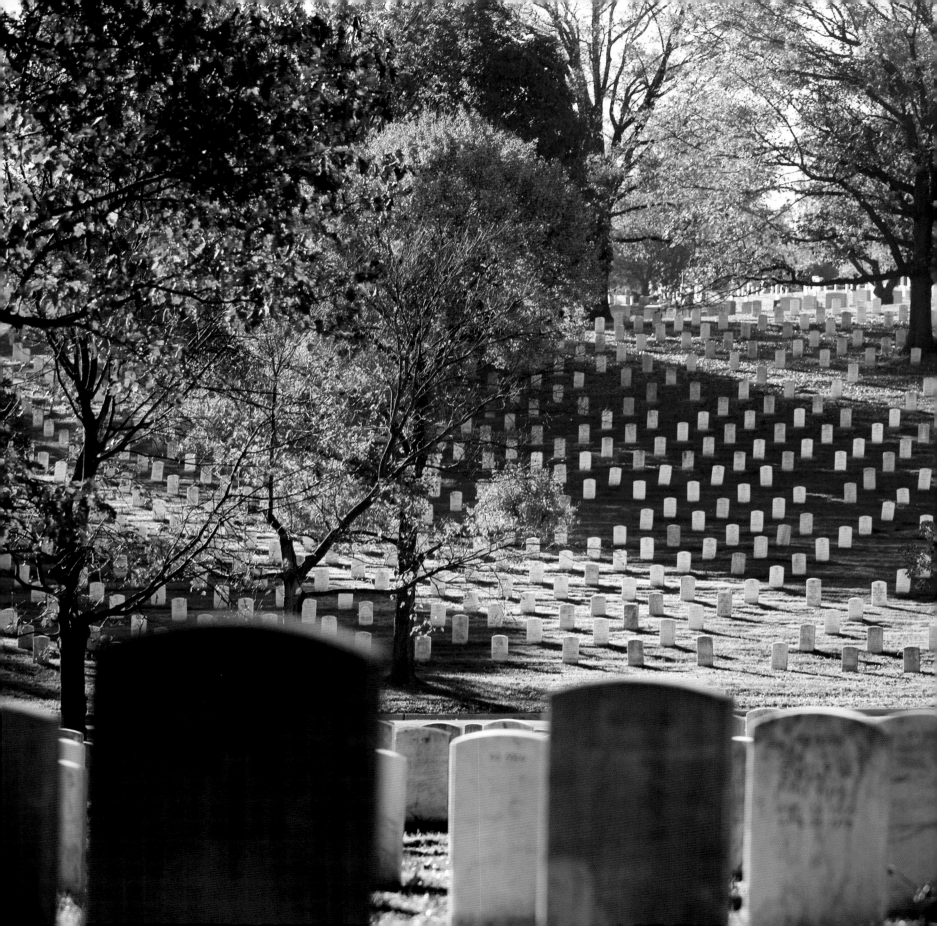

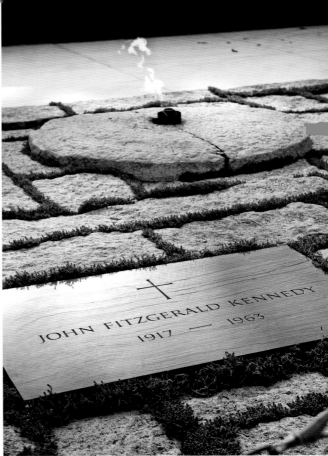

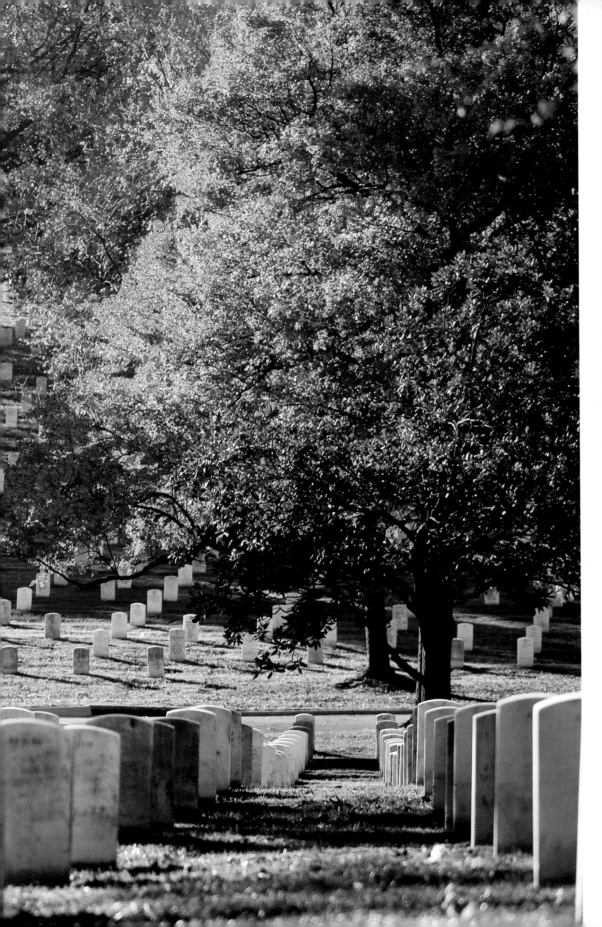

Six hundred and twenty-four hilly, wooded acres overlooking the city from the west side of Memorial Bridge make up Arlington National Cemetery. Five-star generals, such as John J. Pershing, and presidents, such as William Howard Taft, are buried alongside the remains of common soldiers and their widows. At the request of his wife, Jacqueline, John F. Kennedy's gravesite includes an eternal flame (above) similar to that of the French Unknown Soldier in Paris.

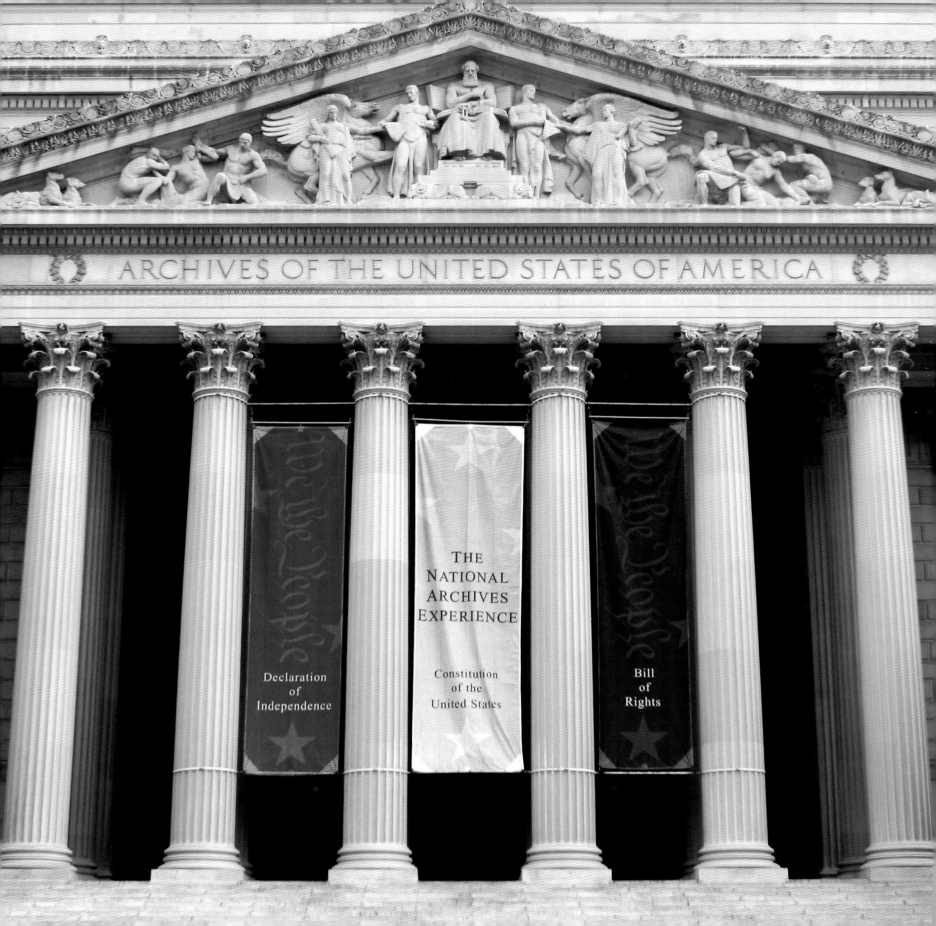

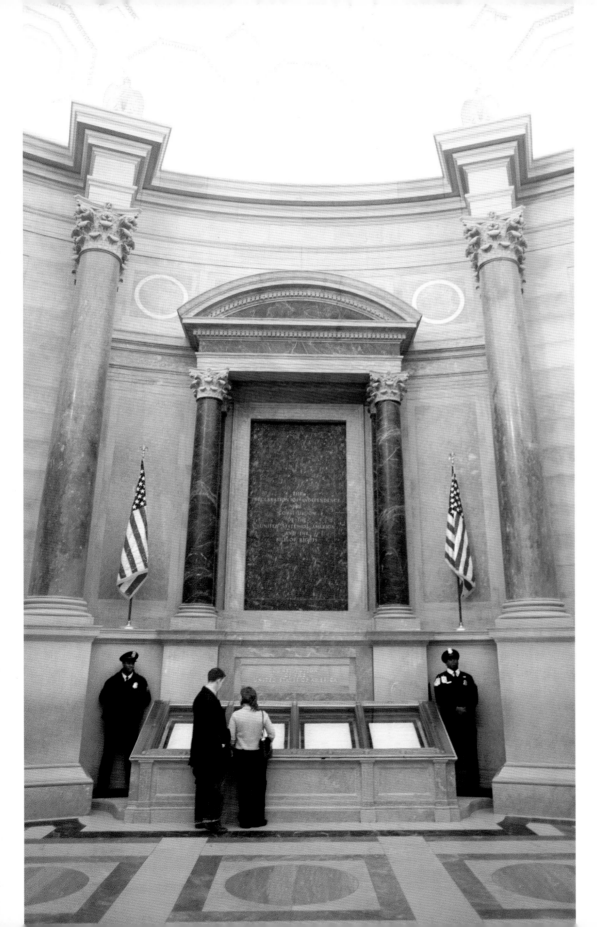

The collection within the National Archives and Records Building includes a staggering eight billion paper records and four billion electronic ones. Although it serves as a public research resource, the Archives also prominently displays some of the nation's most important original documents, including the Declaration of Independence, the Constitution of the United States and the Bill of Rights.

OPPOSITE PAGE: The National Archives and Records Building was designed in the Neoclassical style by John Russell Pope, who was also the architect of the National Gallery of Art and the Jefferson Memorial.

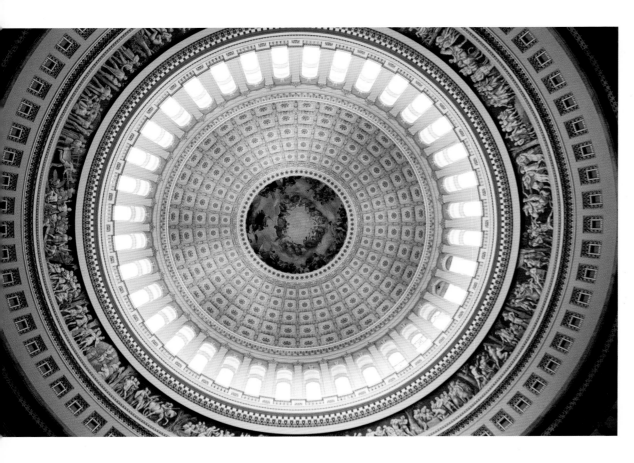

The enormous fresco, *The Apotheosis of Washington*, completed in 1865 by Italian artist Constantino Brumidi, caps the Capitol's 96-foot-diameter Rotunda. It was completed during the dark days of the Civil War, and beneath it presidents and a few other national heroes have lain in state. The line to view President Kennedy's casket was 10 people wide and stretched for an incredible 40 blocks.

RIGHT: George Washington laid the cornerstone of the Capitol on September 18, 1793, but work on the building continued for many decades to come. During the War of 1812, the Capitol was gutted by fire. Reconstruction was not completed until 1826, and in 1855 work began on the dome we know today.

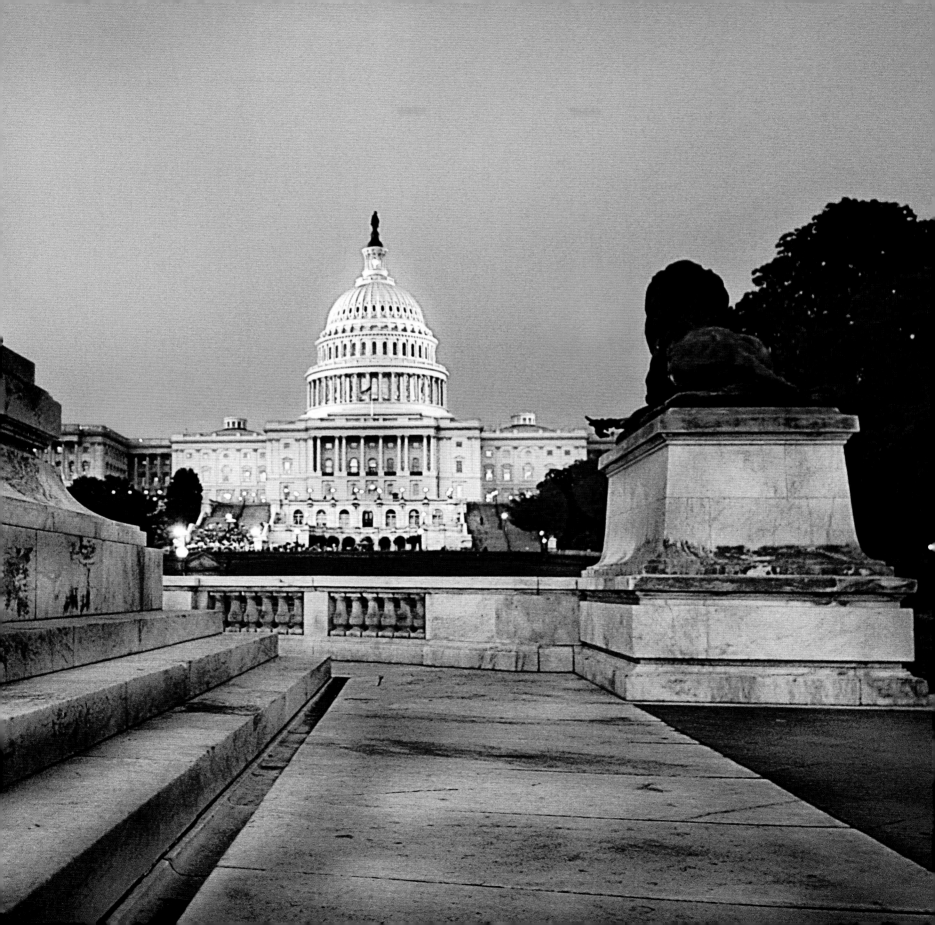

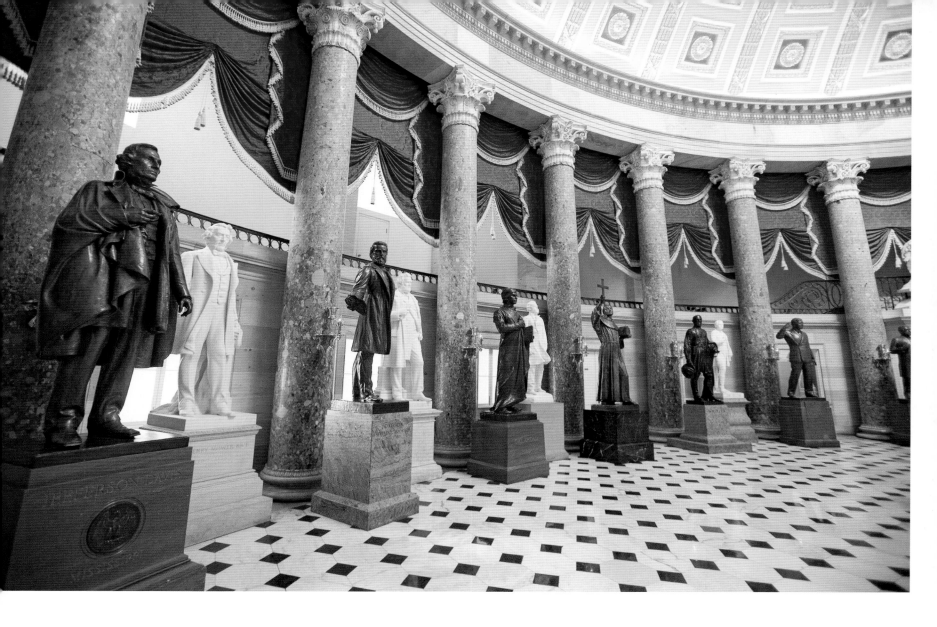

A visit to the National Capitol is part of any trip to Washington DC, and a tour through the Rotunda, Statuary Hall and Crypt showcases not only beautiful classical architecture, but history itself. Visitors learn about the great decisions in the very halls where many of them occurred.

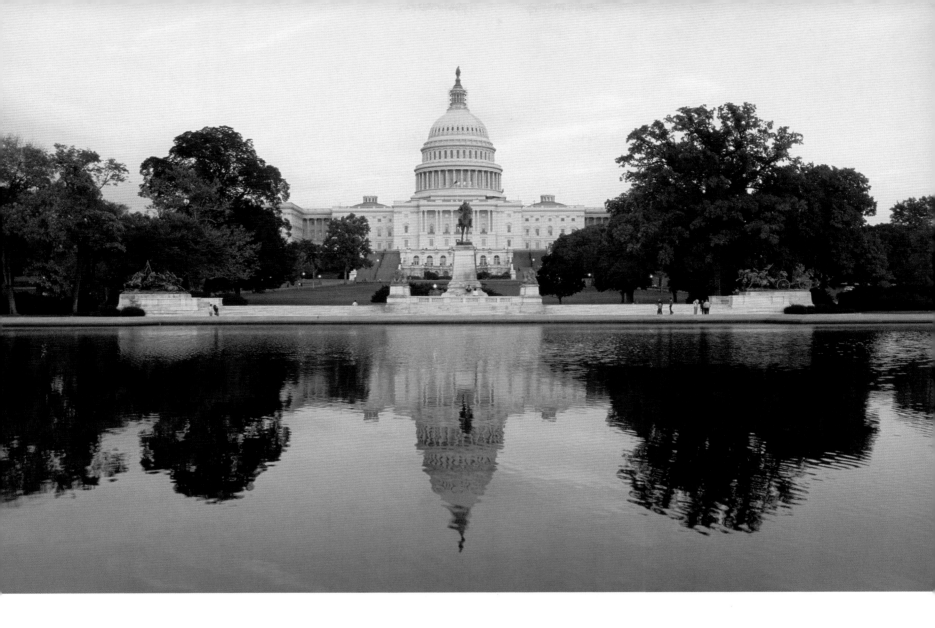

The Capitol and the Ulysses S. Grant Memorial are reflected in the Capitol Reflection Pool. The bronze equestrian portrait of Grant honors the Civil War general and 18th president of the United States.

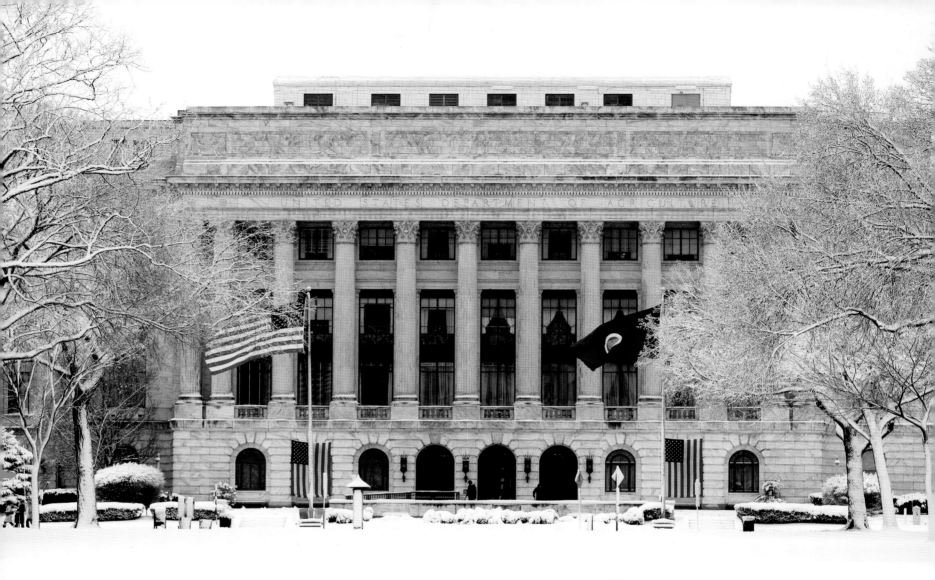

Designed in the Neoclassical style and completed in 1930, the Department of Agriculture Whitten Building is the only Cabinet-level agency building located on the National Mall.

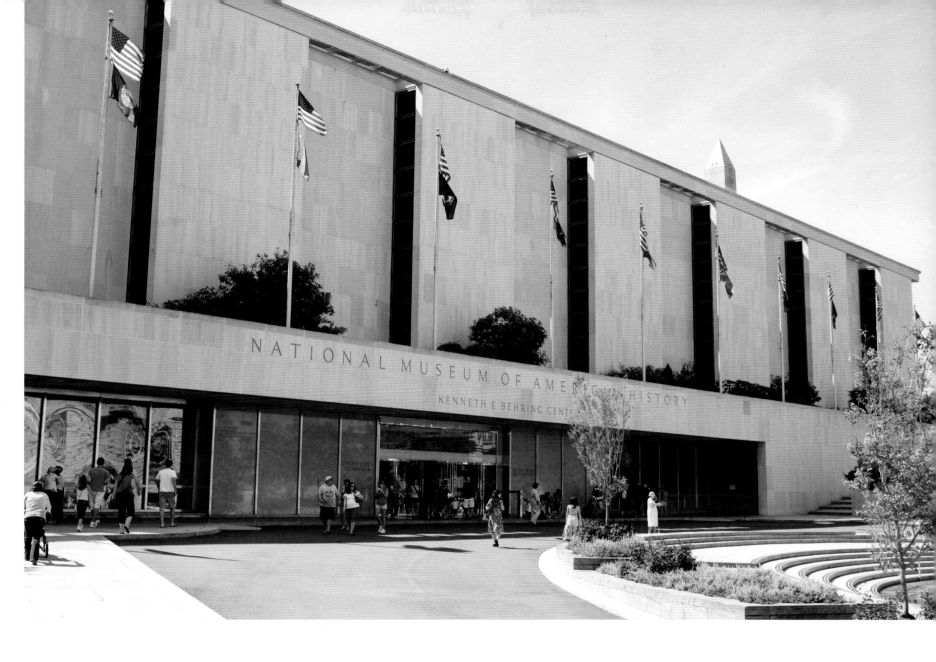

The National Museum of American History holds some of the country's most revered objects, such as the original "Star-Spangled Banner," and some of its most beloved, such as Dorothy's ruby slippers from the *The Wizard of Oz*. First opened in 1964 as the Museum of History and Technology, the building has recently undergone an $85 million renovation.

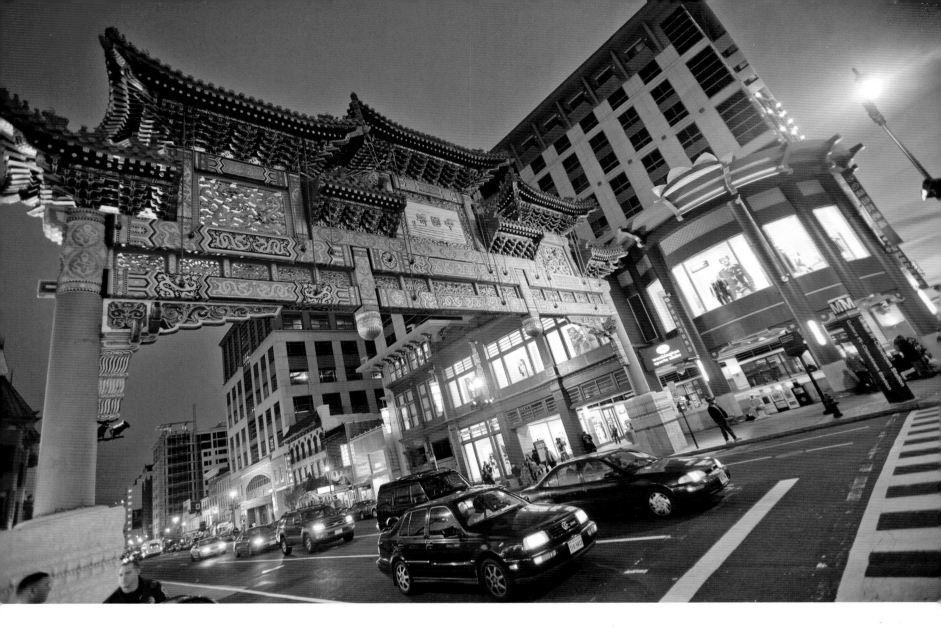

Chinatown is a small historic neighborhood anchored by numerous Asian restaurants and the Verizon Center. In 1986, the city spent $1 million on this dramatic Friendship Archway with its seven roofs, 272 painted dragons and more than seven thousand tiles.

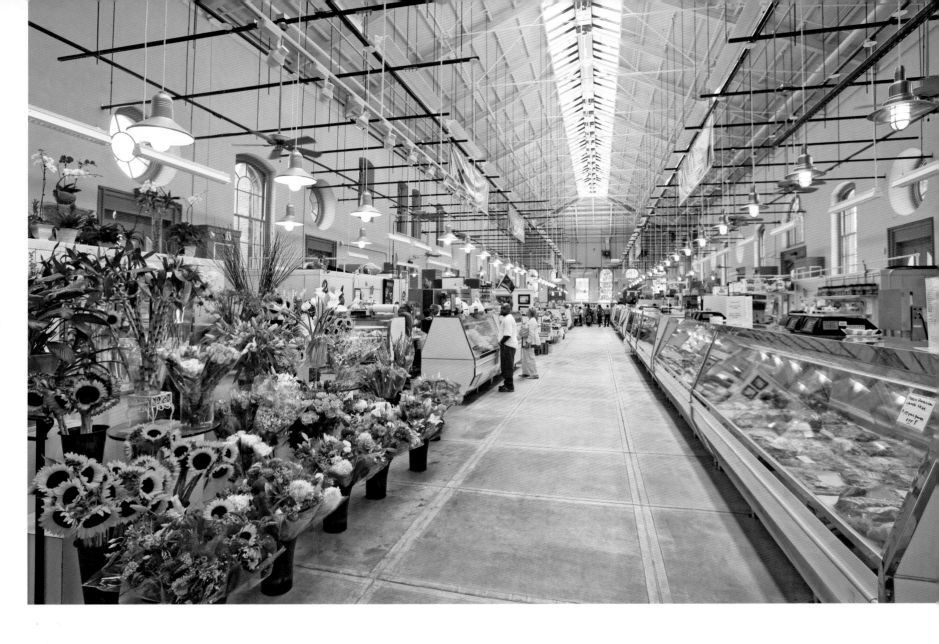

An April 2007 fire devastated the Eastern Market, a Capitol Hill institution that had been operating since 1873. After a rebuilding program, the market reopened on June 26, 2009. Locals and tourists alike have returned to the stalls of greengrocers, butchers, bakers, florists and craftspeople.

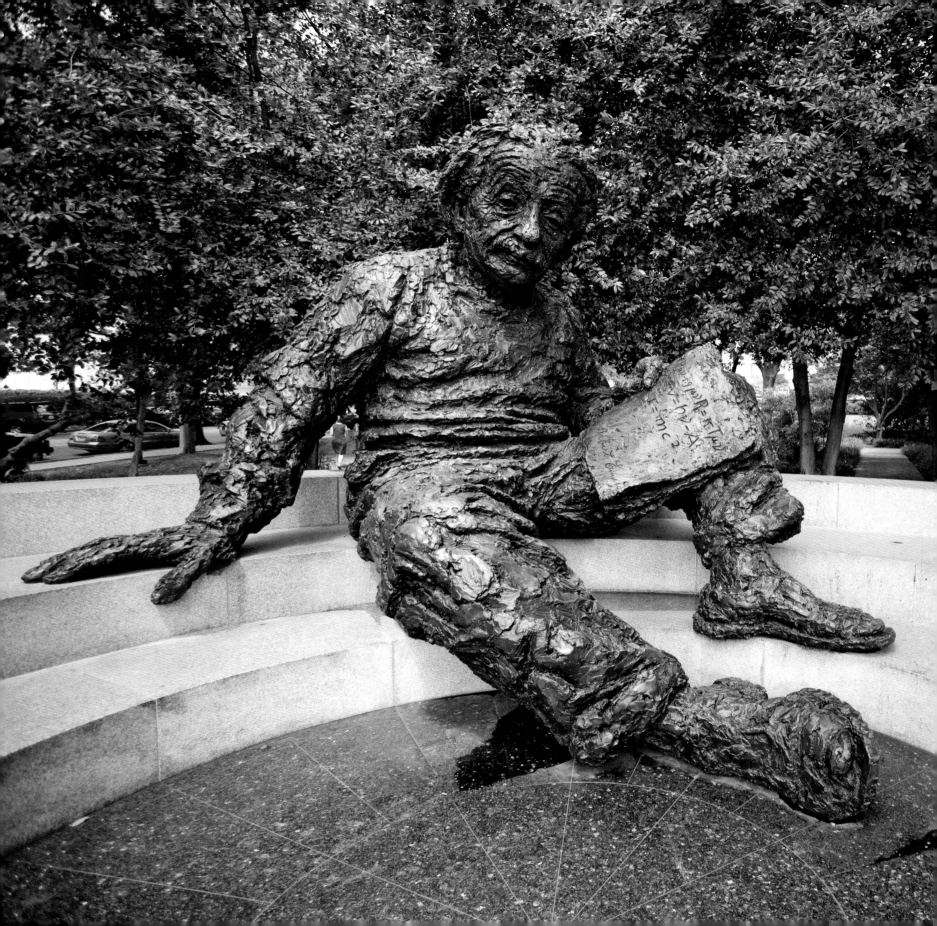

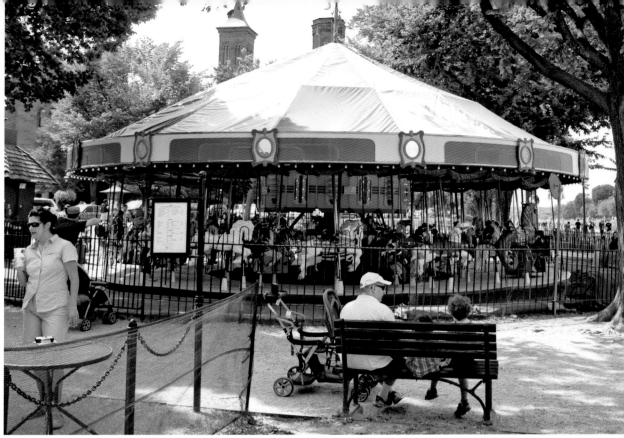

ABOVE: The carousel outside the Arts and Industries Building on the National Mall was built in 1947 and originally installed in Baltimore. In 1981, it was moved to its present location to replace a badly aging carousel installed in the 1960s.

LEFT: The Albert Einstein Memorial is a monumental bronze statue of the great scientist, located on the grounds of the National Academy of Sciences. This 12-foot statue shows Einstein seated on a granite bench and holding in one hand a paper filled with his most famous mathematical formulas.

Dupont Circle connects the main thoroughfares of Massachusetts, New Hampshire and Connecticut Avenues. In the center of this busy area, known for its historic homes and trendy restaurants, is a beautiful marble fountain installed in 1921.

Tourists and locals snapping photos of the Tidal Basin's stunning cherry trees (more than 3,700 in all!) is a common sight in Washington during the trees' two-week blooming period. Cherry blossom festivals are held in several parks, and the blooming period begins, on average, April 4.

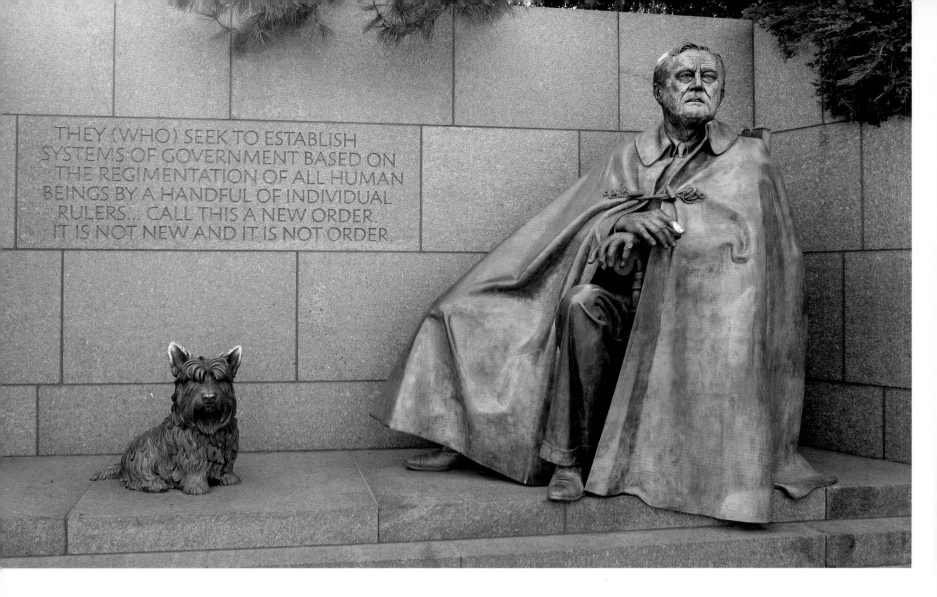

THEY (WHO) SEEK TO ESTABLISH
SYSTEMS OF GOVERNMENT BASED ON
THE REGIMENTATION OF ALL HUMAN
BEINGS BY A HANDFUL OF INDIVIDUAL
RULERS... CALL THIS A NEW ORDER.
IT IS NOT NEW AND IT IS NOT ORDER.

The Franklin Delano Roosevelt Memorial, dedicated in 1997 by President Bill Clinton, is found along the famous Cherry Tree Walk on the western edge of the Tidal Basin. This statue of President Roosevelt along with his dog, Fala, is part of a series of four outdoor rooms that depict FDR and his years as president.

OPPOSITE PAGE: Washington's Embassy Row was an affluent residential address during the 19th and early 20th centuries. Following the Second World War, many of the great mansions that had fallen into disrepair during the Great Depression were adapted to serve as embassies.

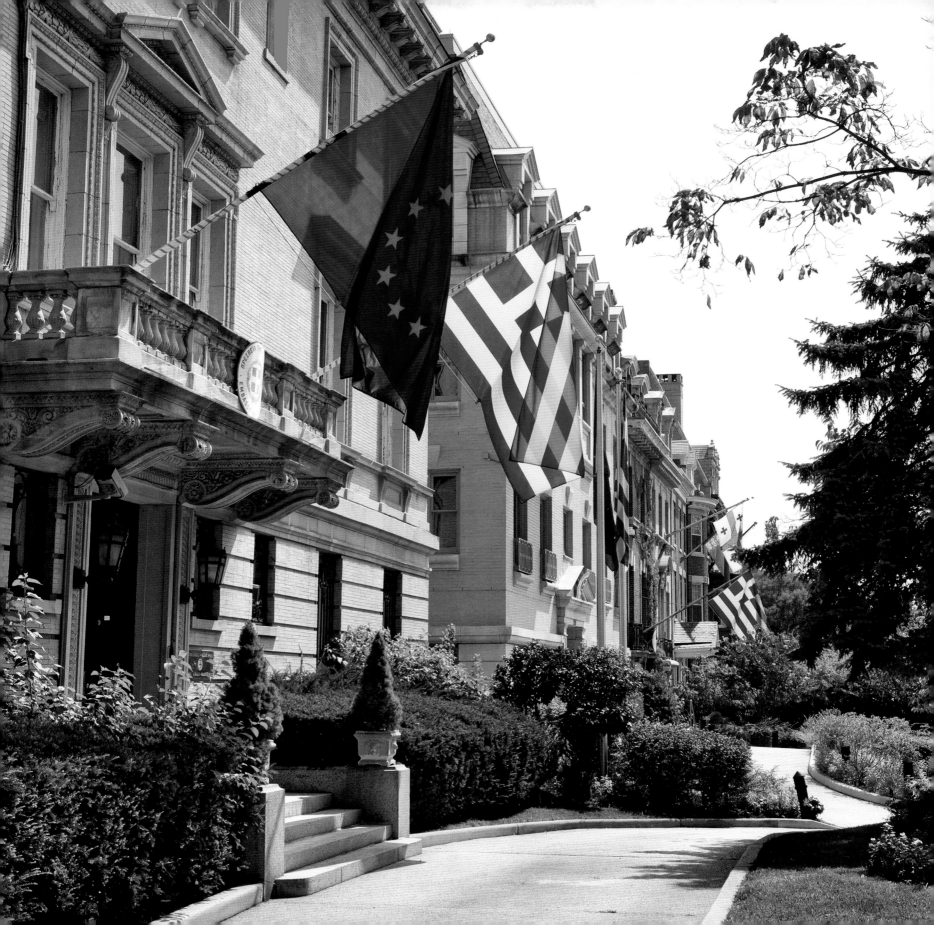

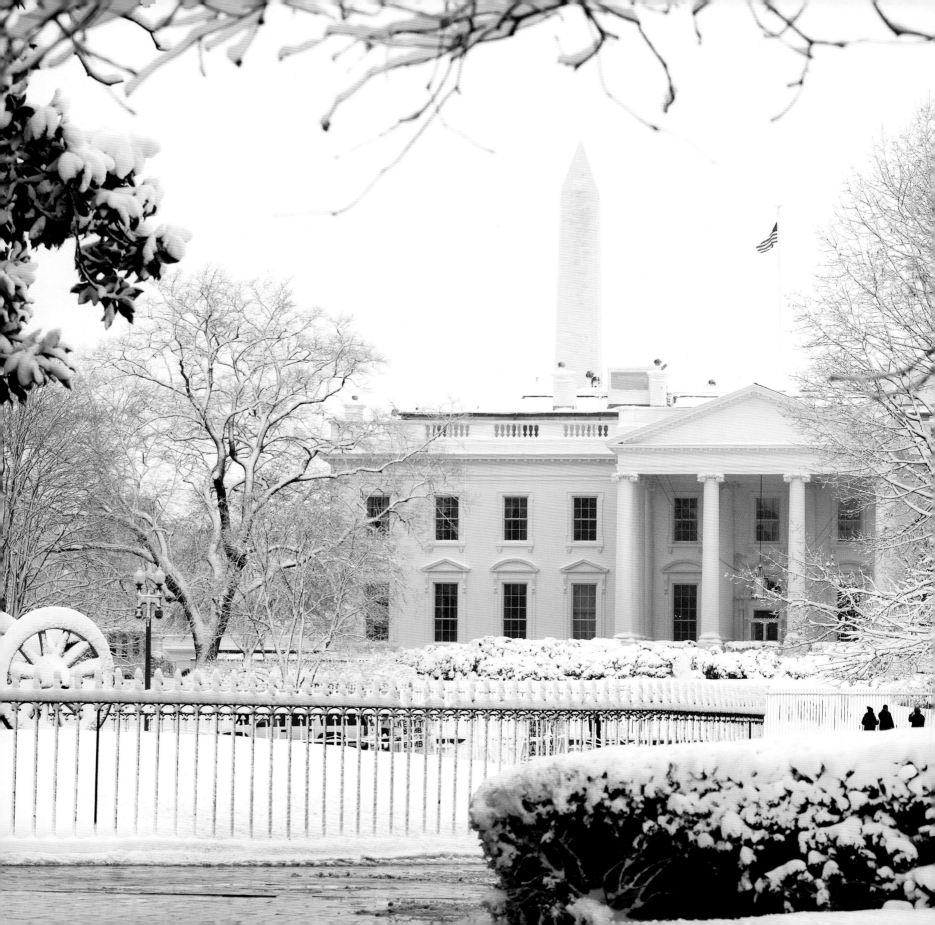

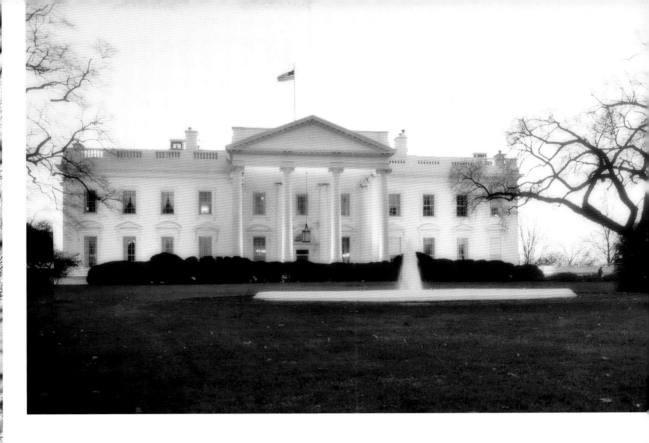

Construction on the White House, designed by Irish-born architect James Hoban, began in 1792 and took eight years to complete. The building, which has undergone several renovations, was originally called the President's House. But the practice of whitewashing – first used by stonemasons on the building in 1798 – gave rise to the name by which we know it today. President John Adams became the first resident of the unfinished White House on November 1, 1800. Since then, the building has served as residence, office and reception site for every president, becoming a symbol to which many Americans feel a strong connection. President Franklin D. Roosevelt wrote, "I never forget that I live in a house owned by all the American people."

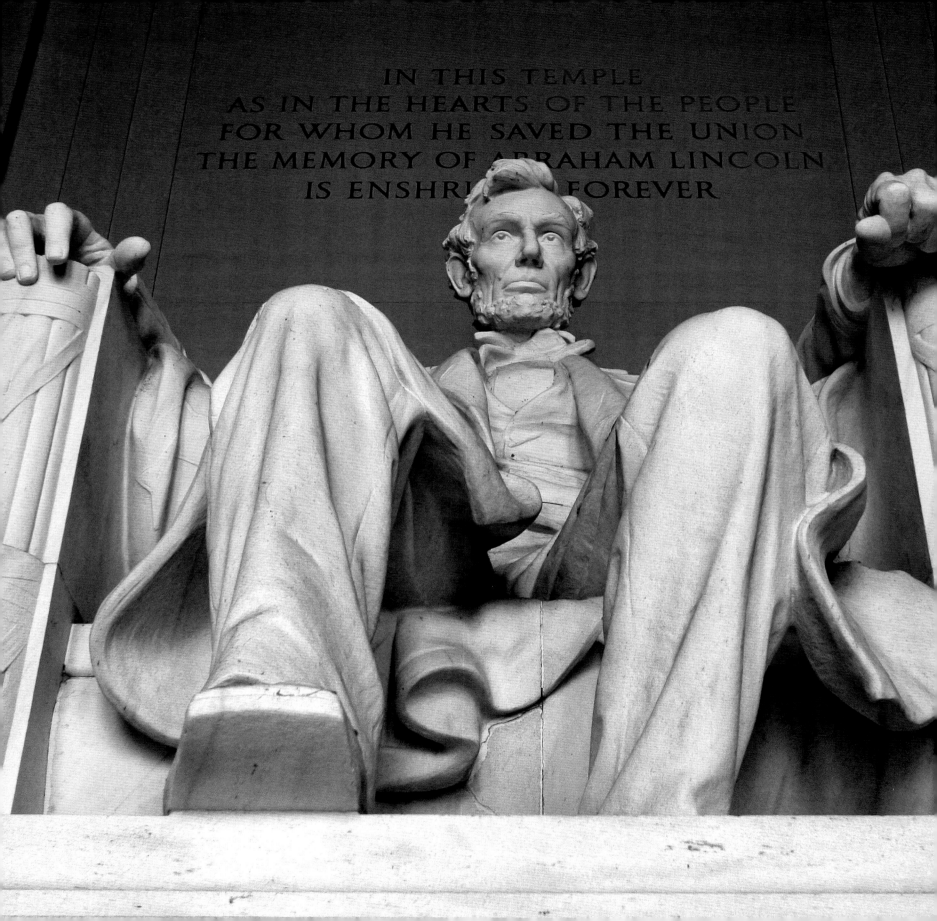

IN THIS TEMPLE
AS IN THE HEARTS OF THE PEOPLE
FOR WHOM HE SAVED THE UNION
THE MEMORY OF ABRAHAM LINCOLN
IS ENSHRINED FOREVER

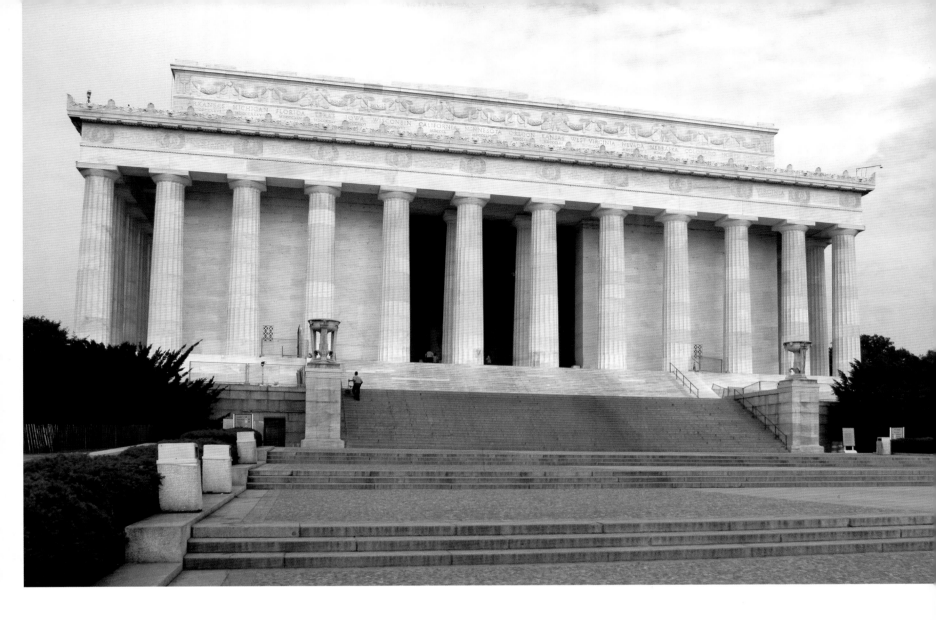

Designed in the Neoclassical style, the Lincoln Memorial was opened to the public in 1922. It has been the site of numerous demonstrations and rallies, most famously the March on Washington for Jobs and Freedom on August 28, 1963, when Martin Luther King Jr. delivered his famous "I have a dream" speech.

OPPOSITE PAGE: The limestone walls of the Lincoln Memorial's inner chamber, surrounding Daniel Chester French's famous statue of the president, are inscribed with the Gettysburg Address and Lincoln's Second Inaugural Address. A set of allegorical murals depicts Lincoln's achievements and values.

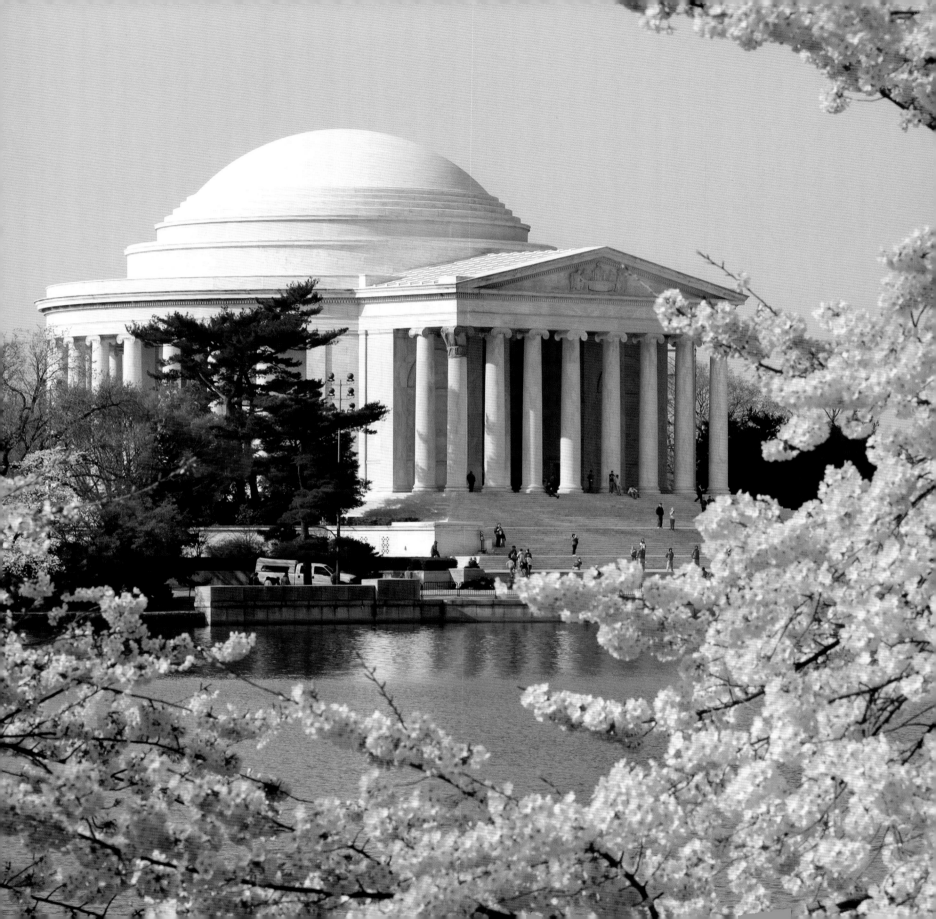

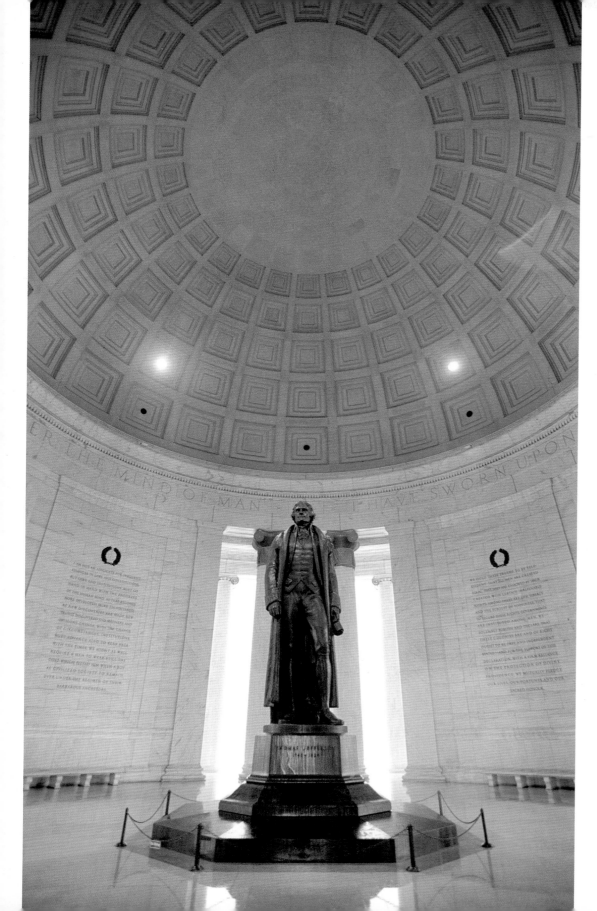

In 1941, sculptor Rudolph Evans was commissioned to design a statue of Jefferson to fill the central interior space of the Jefferson Memorial. The 19-foot likeness looks out from beneath the dome toward the White House in the distance.

OPPOSITE PAGE: Franklin Roosevelt, who greatly respected Thomas Jefferson, spearheaded an effort to build him a memorial. Land was reclaimed from the Potomac River, and the cornerstone laid in 1939. Roosevelt so admired the classically designed structure that he had all the trees between it and the White House cut down, allowing him to see it every morning.

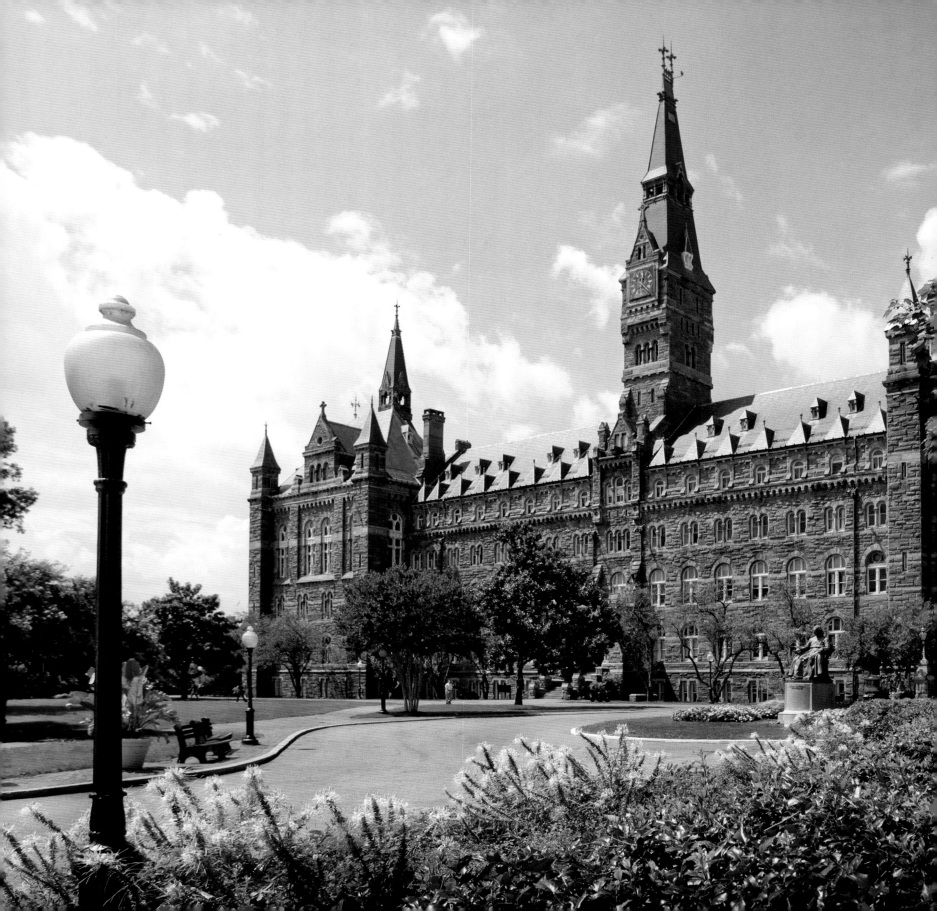

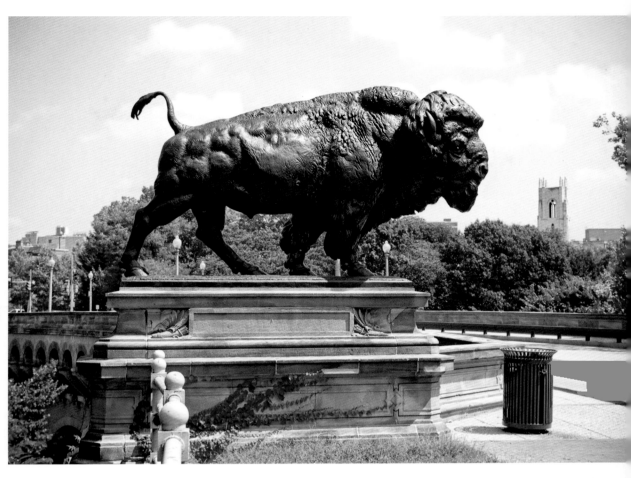

ABOVE: Known as the Dumbarton Bridge, Q Street Bridge and Buffalo Bridge, this historic feat of engineering spans Rock Creek Park, connecting the city's Dupont Circle and Georgetown neighborhoods. Built between 1914 and 1915, the bridge is most famous for its four buffalo sculptures.

LEFT: Georgetown University's Healy Hall is listed on the National Register of Historic Places and remains the school's flagship building. The building is named for the school's 29th president, Patrick Healy, the first African-American president of a U.S. university.

Georgetown's picturesque Chesapeake & Ohio Canal is one of numerous canals built across the country to improve trade. When a nearby railroad made the C & O Canal obsolete, it fell into disrepair and was only saved from being turned into a superhighway by the efforts of Supreme Court Justice William O. Douglas and others. Today the area is a national historic park.

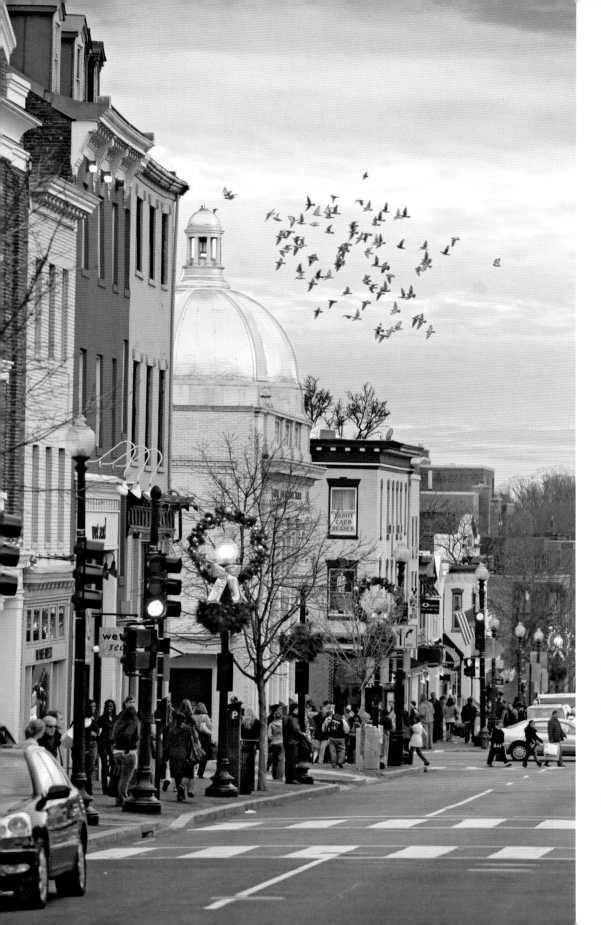

The two main thoroughfares of beautiful Georgetown, M Street and Wisconsin Avenue, intersect at the heart of this historic and well-to-do Washington neighborhood. High-end clothing boutiques, antique stores and trendy restaurants fill the main streets of the neighborhood, also known for its picturesque townhouses, redbrick sidewalks and pleasant gardens.

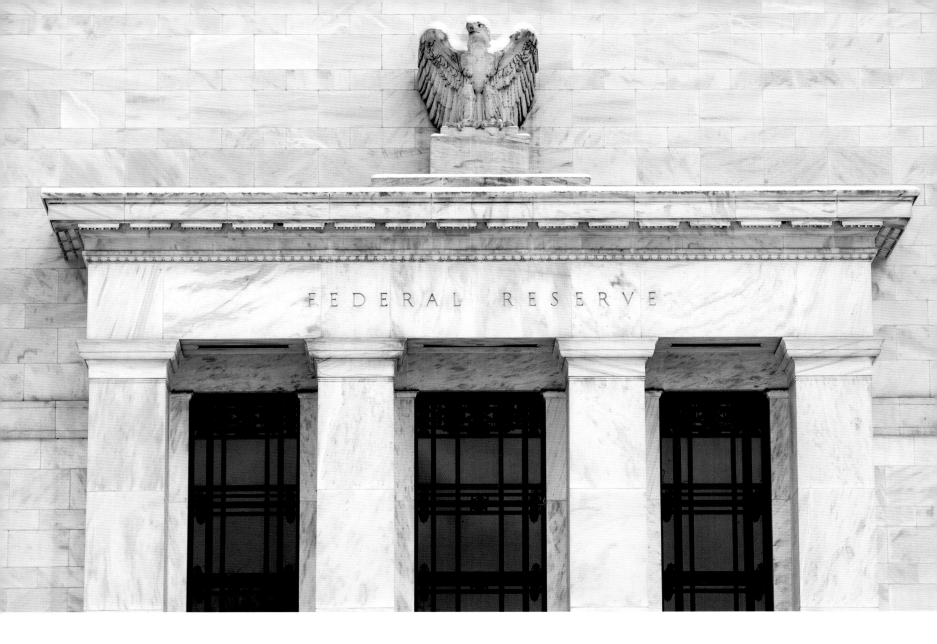

The Federal Reserve Building is an imposing marble structure known for its massive bronze entranceway topped by a dramatic eagle sculpture. Despite the name, no money is kept here. The Federal Reserve is mainly responsible for setting interest rates.

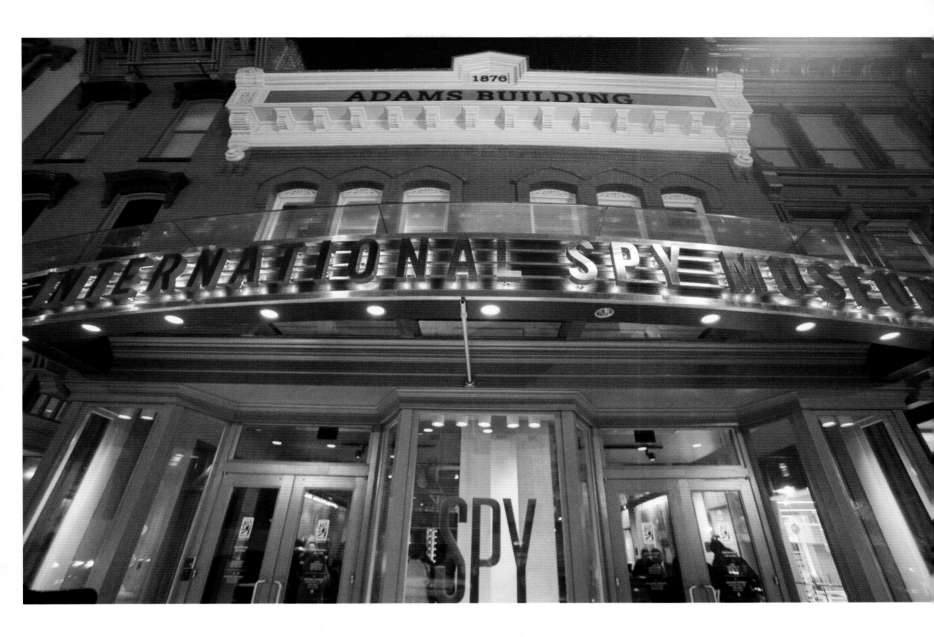

The International Spy Museum is the only public museum in the United States dedicated solely to the art and adventure of espionage. Besides tools of the trade (both ancient and modern), biographies of famous spymasters and numerous audio-visual displays, the museum boasts interactive exhibits.

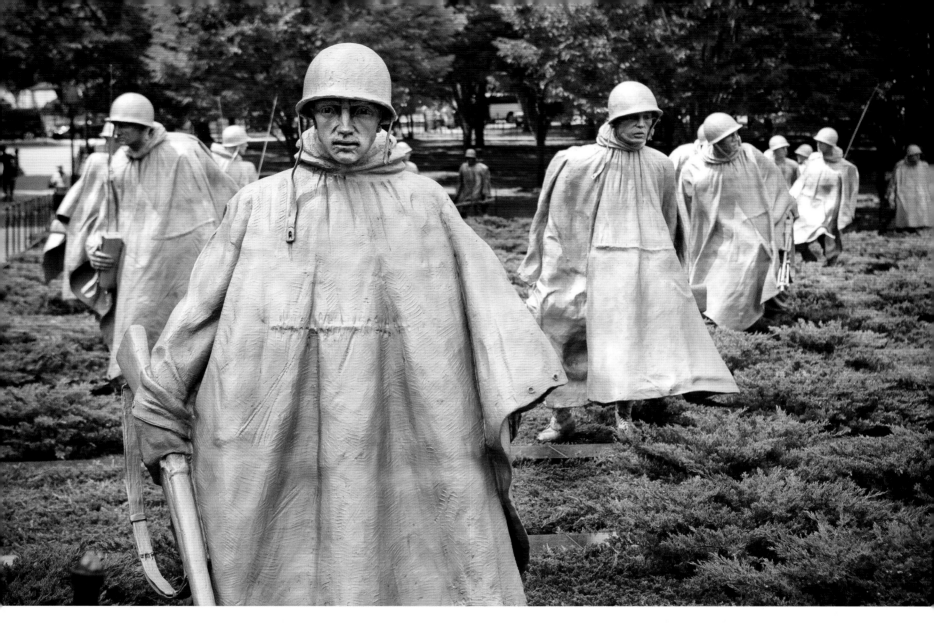

The Korean War Veterans Memorial, privately funded and dedicated in 1995, consists of a circular "Pool of Remembrance" and "Field of Service" studded with 19 lifelike statues of infantrymen on the march.

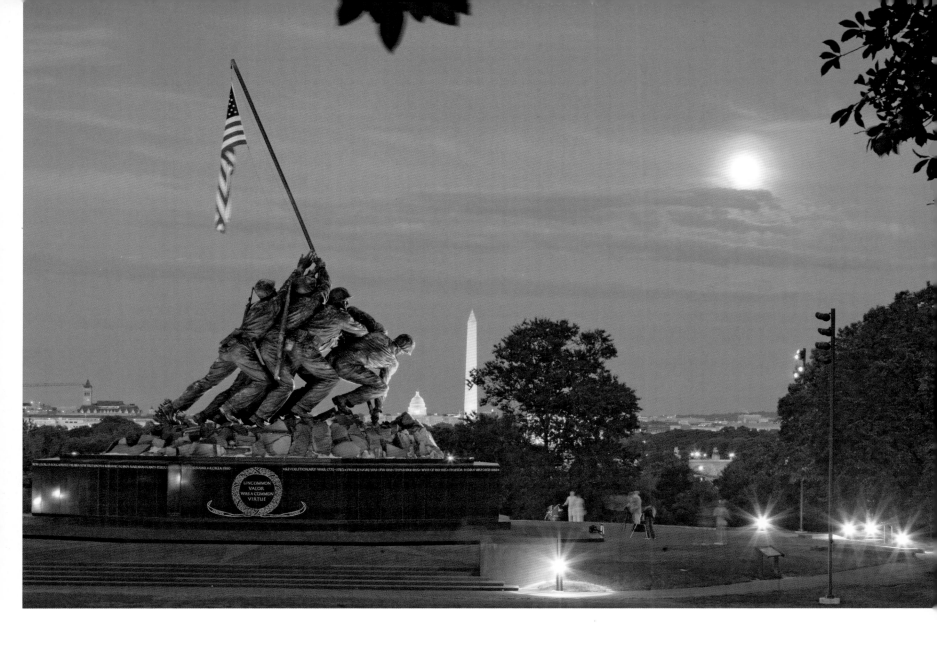

The U.S. Marine Corps War Memorial, commonly known as the Iwo Jima Memorial, is a massive bronze statue outside Arlington National Cemetery. Its design was inspired by Joe Rosenthal's famous photo, *Raising of the Flag on Iwo Jima*, and is dedicated to all personnel in the Marine Corps who have died in defense of their country.

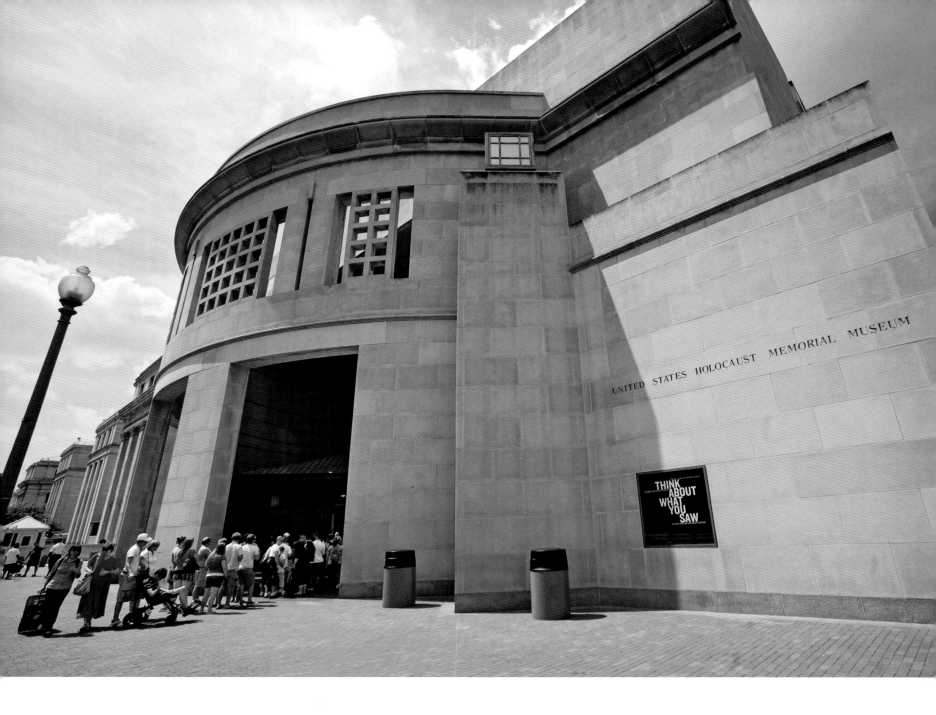

Since its dedication in 1993, the United States Holocaust Memorial Museum has welcomed nearly 30 million visitors. A "living memorial to the Holocaust," the museum, which presents a narrative history using artifacts and eyewitness testimonies, "inspires citizens and leaders worldwide to confront hatred, promote human dignity, and prevent genocide."

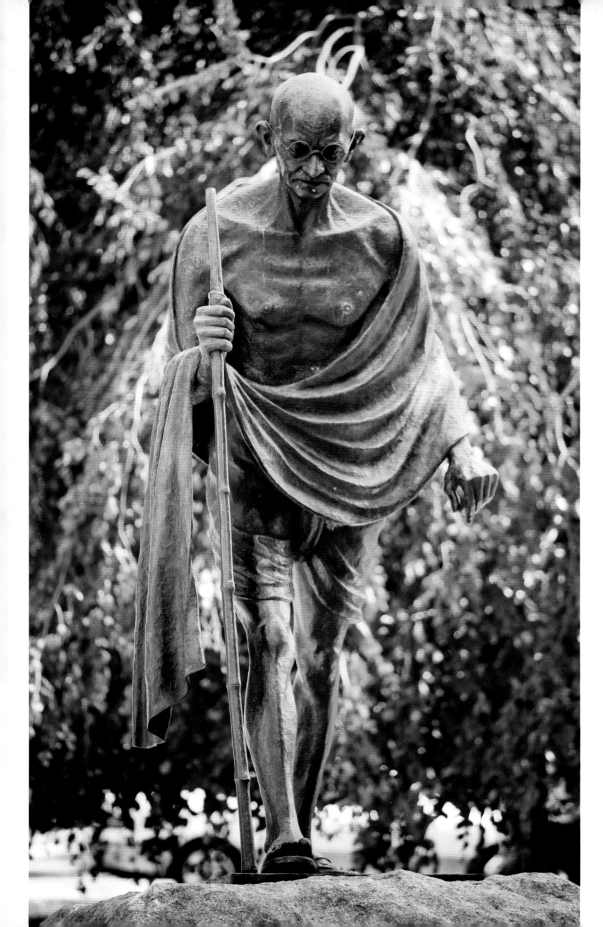

Dedicated in 2000, this statue depicts Mahatma Gandhi, the political and spiritual leader of India during the Indian independence movement and a pioneer of the idea of resistance to tyranny through mass civil disobedience.

FOLLOWING PAGE: The six-lane Francis Scott Key Bridge, named for the man who wrote the words of the "Star-Spangled Banner," was completed in 1923. It is Washington's oldest bridge still spanning the Potomac.

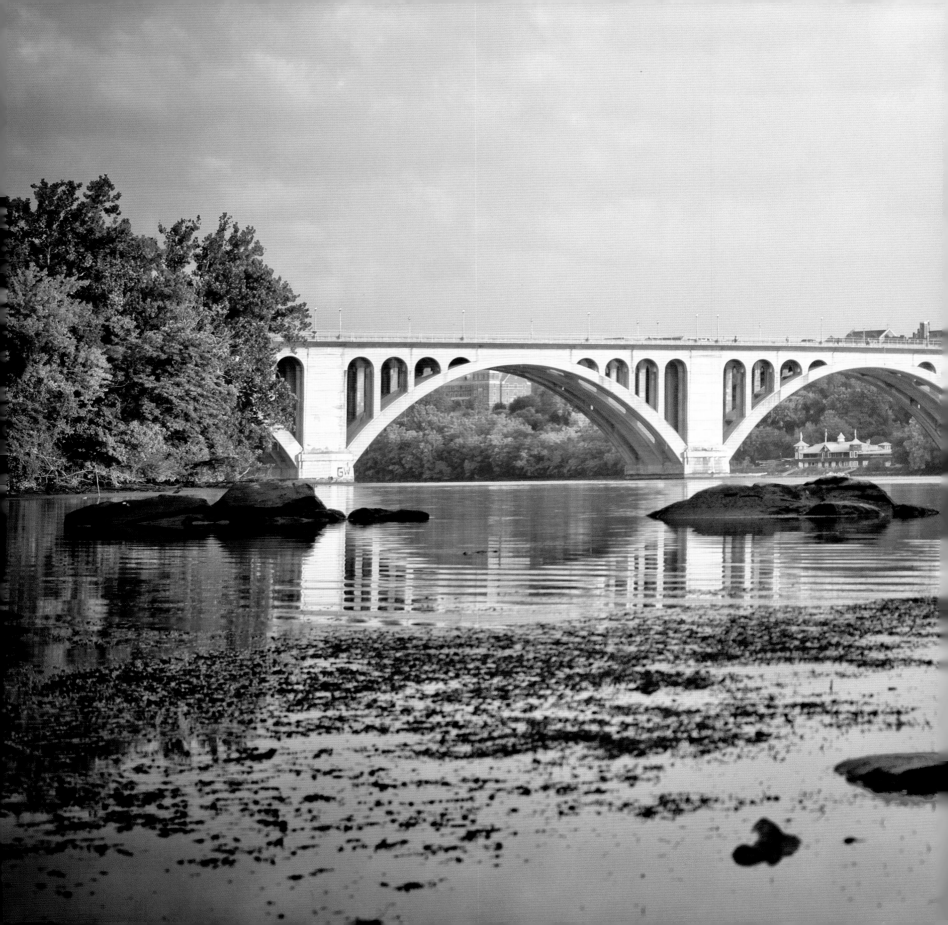

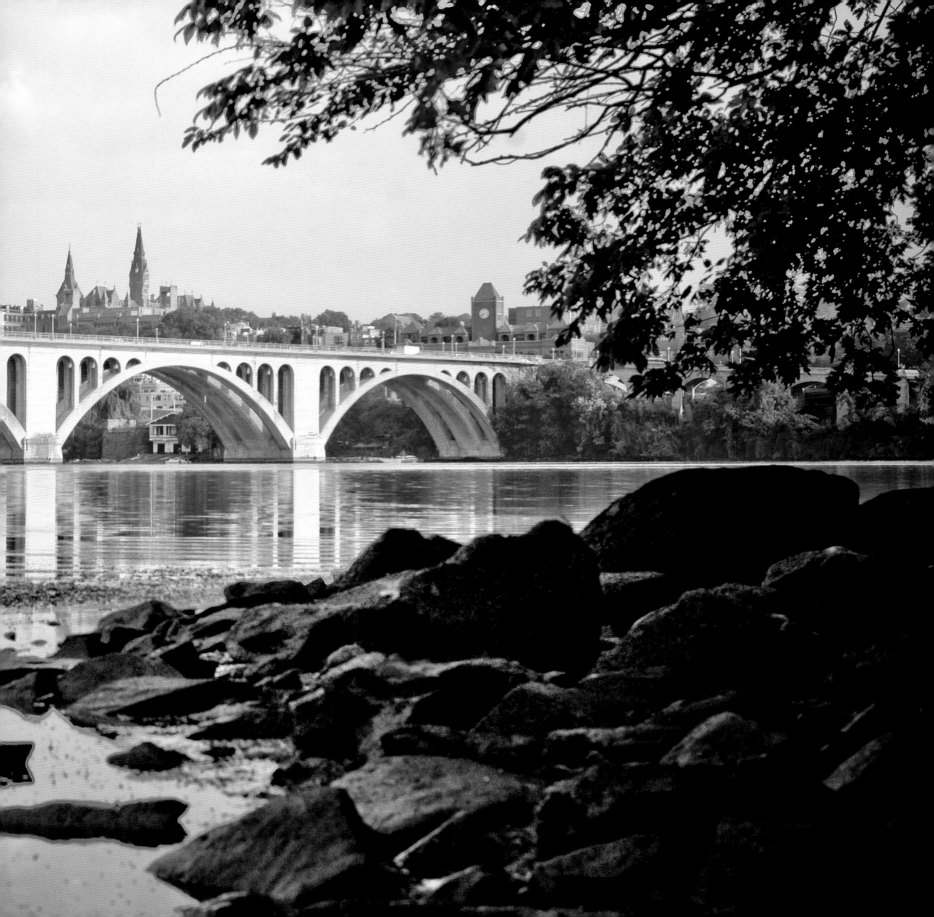

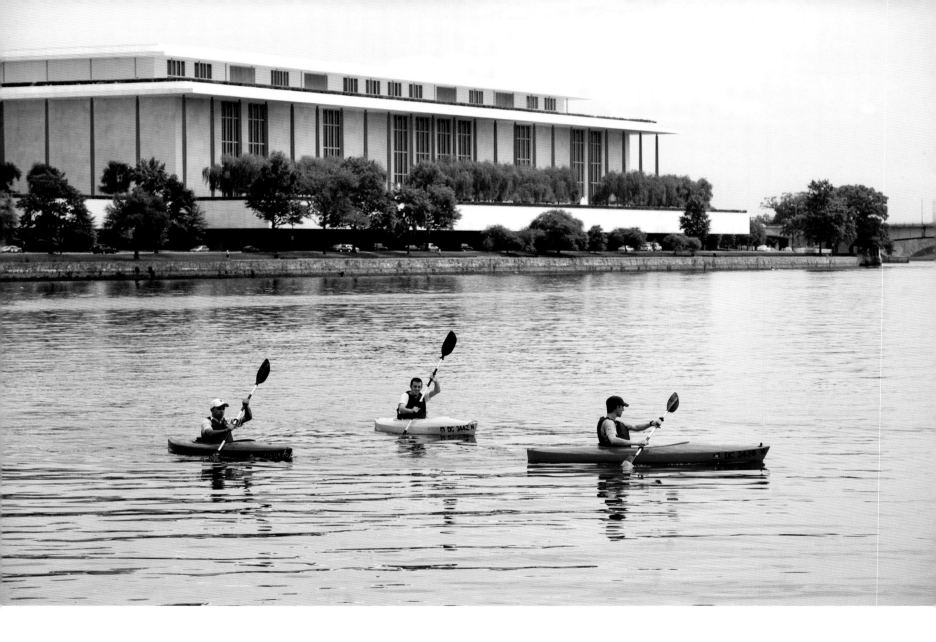

The John F. Kennedy Center for the Performing Arts, located on the banks of the Potomac River, is a national performing arts center with an opera house, concert hall and numerous theaters, and a memorial to the president. The interior of this striking building is filled with art treasures and objects donated by foreign countries in President Kennedy's memory.

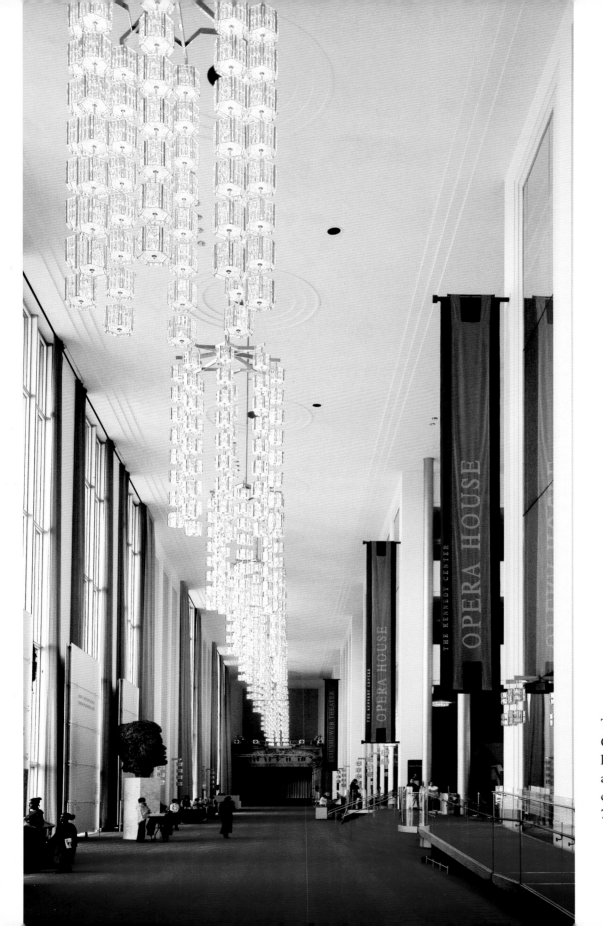

The Grand Foyer of the John F. Kennedy Center for the Performing Arts is one of the largest rooms in the world. At 63 feet high and 630 feet long it could, if laid on its side, contain the Washington Monument – with 75 feet to spare.

Washington, DC | **43**

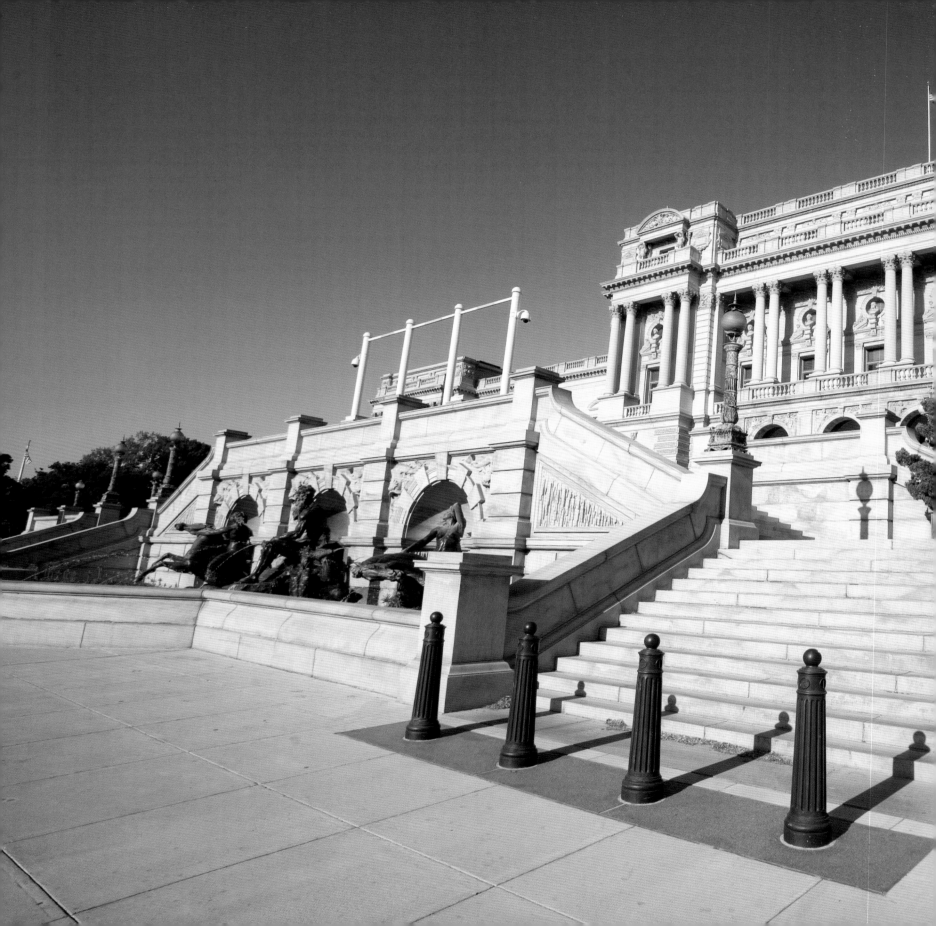

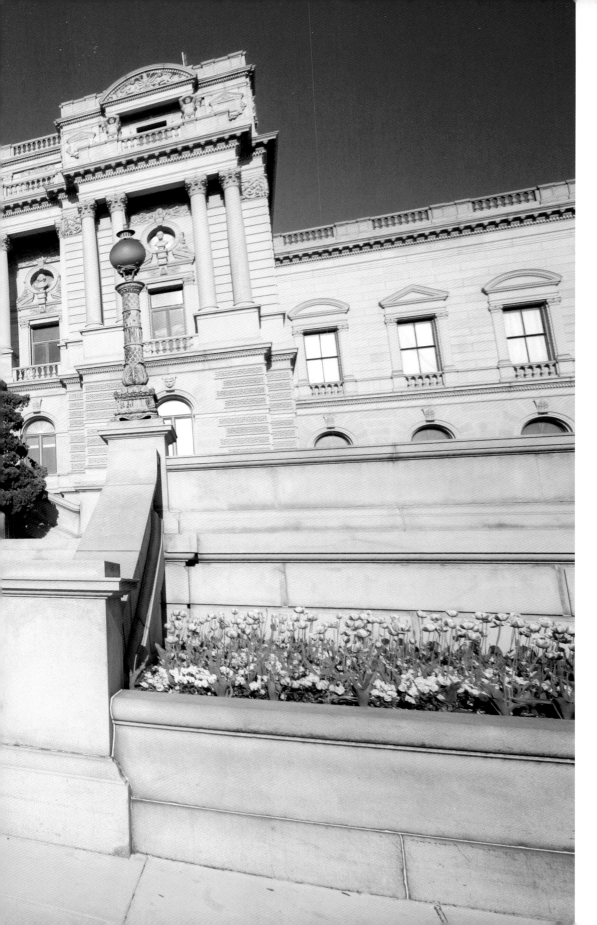

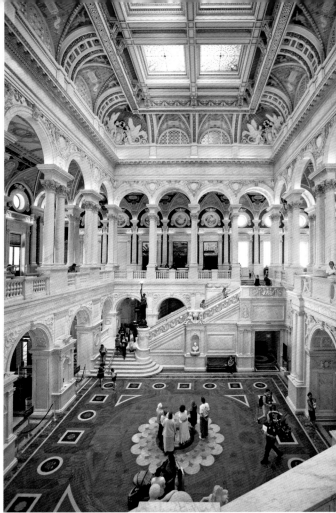

The Thomas Jefferson Building, one of three that compose the Library of Congress, includes the works of sculptors, painters and artisans who worked for eight years to complete the interior's mosaics, stained glass and more than one hundred murals. Open to the public, the library holds 32 million books, 62 million manuscripts and countless prints, photographs and recordings.

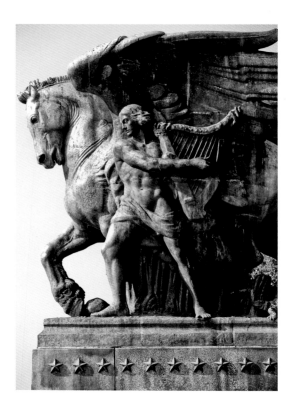

RIGHT: Constructed between 1926 and 1932, the Arlington Memorial Bridge, which marks the end of the Mall and leads to Arlington National Cemetery, is composed of nine broad arches that stretch 2,163 feet over the Potomac River. Adorned with statuary, the bridge is generally considered to be the city's most beautiful. Two 17-foot pairs of bronze equestrian statues (above) mark the ends of the structure.

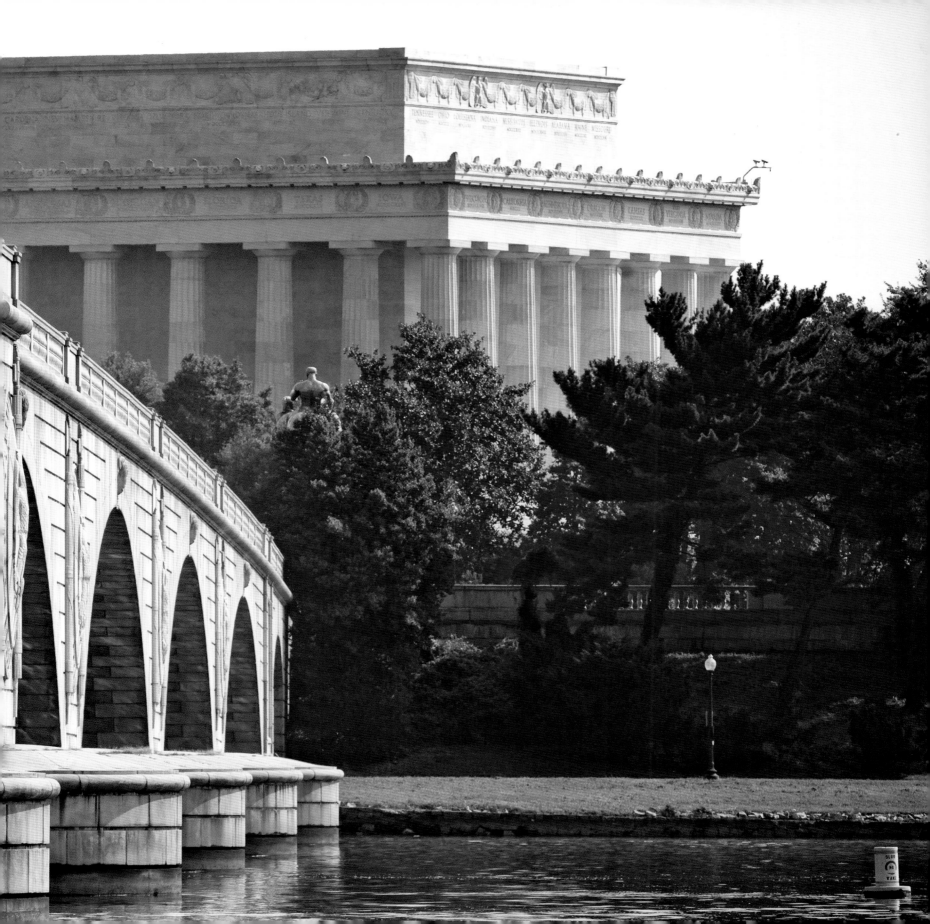

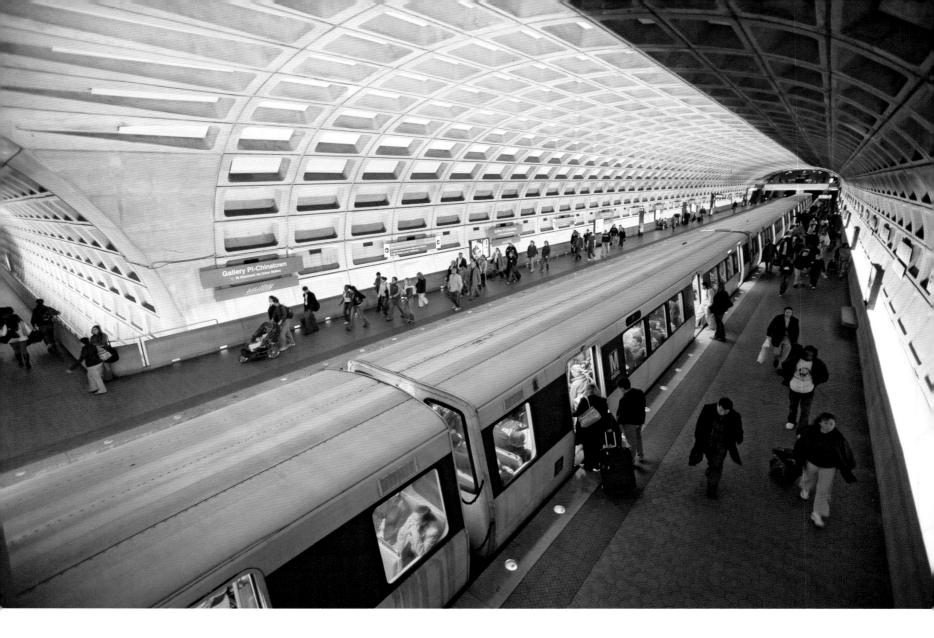

Since opening in 1976, the Washington Metro has become the second-busiest rapid transit system in the United States. There are 86 stations and more than 100 miles of rail. The highest ridership for a single day was on the day of Barack Obama's inauguration, January 20, 2009, with more than 1.1 million riders.

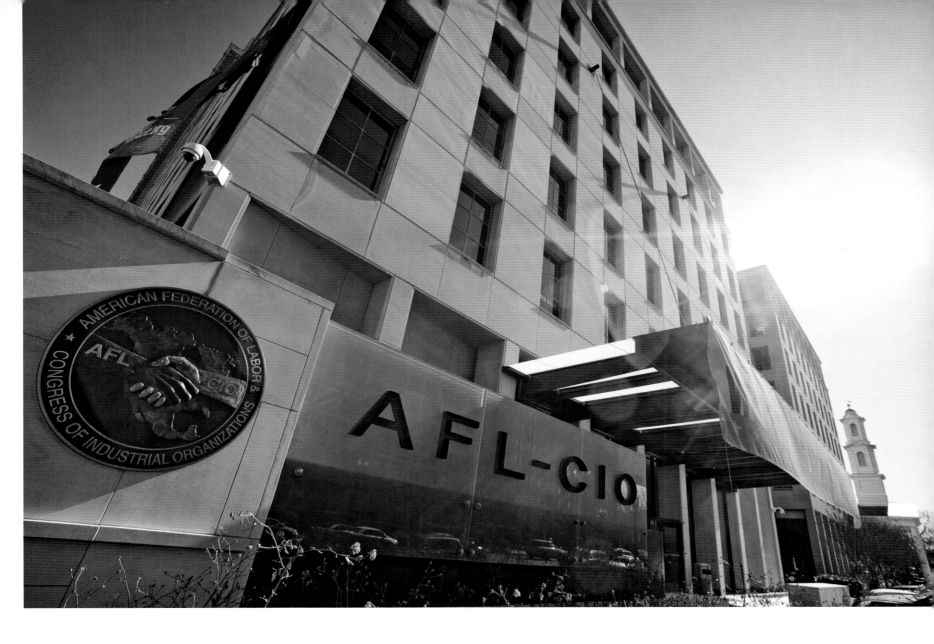

The American Federation of Labor and Congress of Industrial Organizations, commonly referred to as AFL-CIO, aims to improve the lives of working families across America by organizing unions and maintaining a strong political voice.

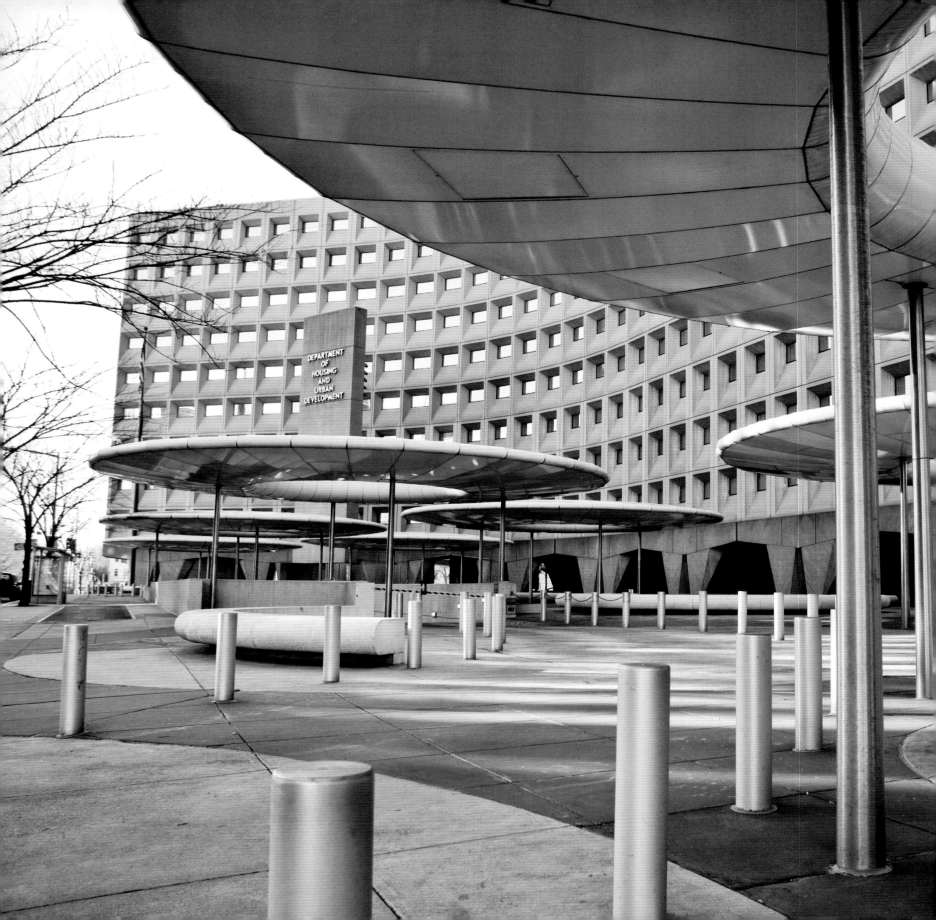

LEFT: The origins of the Department of Housing and Urban Development began with the passing of the *Housing Act* in 1937. Since that time, HUD has become a Cabinet-level agency with the goal of increasing home ownership and supporting community development.

The United States Tax Court is a court of record that Congress established under Article I of the U.S. Constitution. It received its present designation in 1942, but was first brought to life with the *Revenue Act* of 1924.

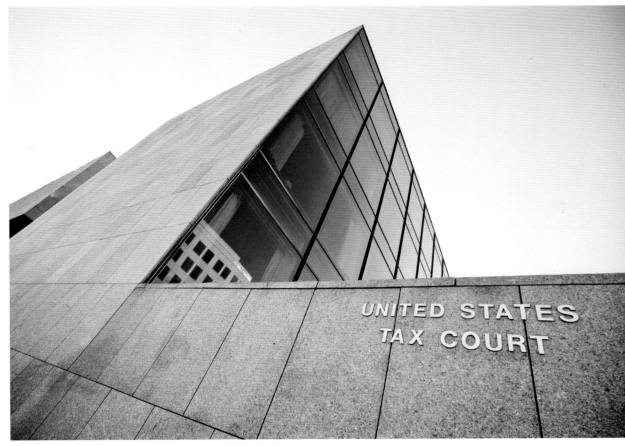

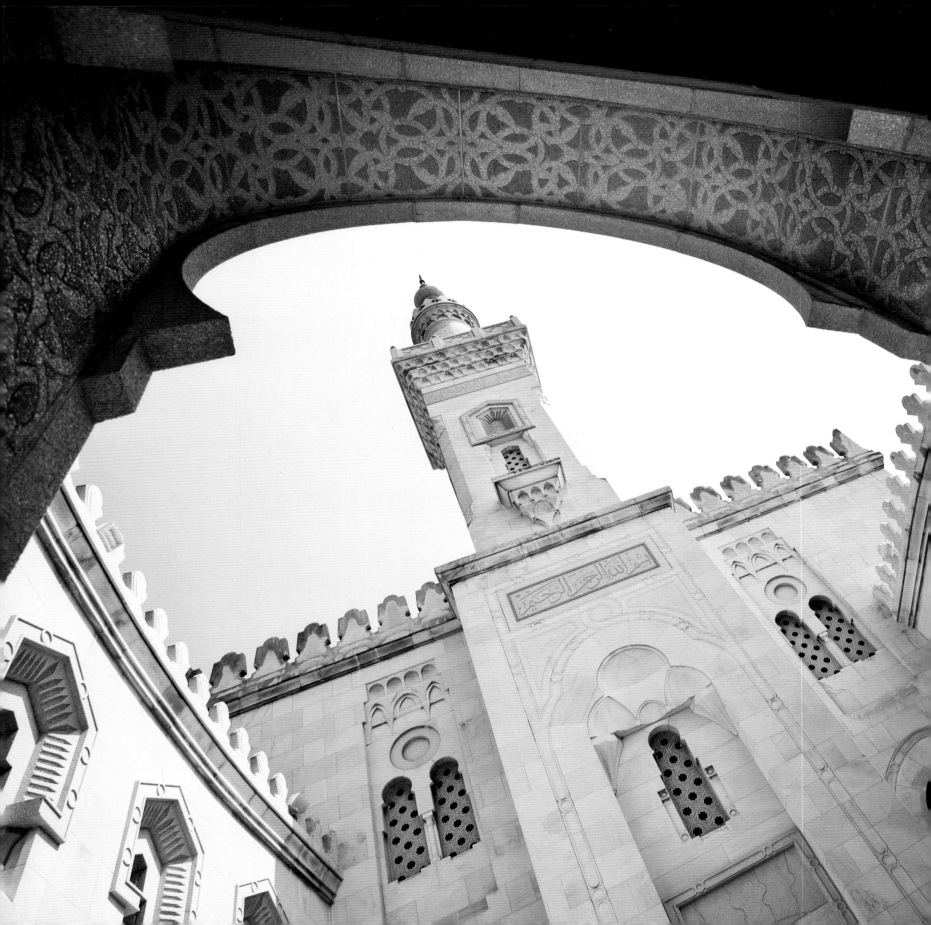

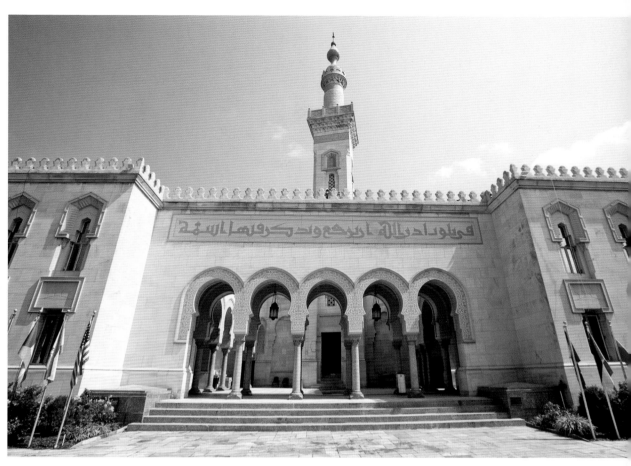

The Islamic Mosque and Cultural Center, with its striking 162-foot minaret, was dedicated in 1957, making it the oldest Islamic place of worship in the city.

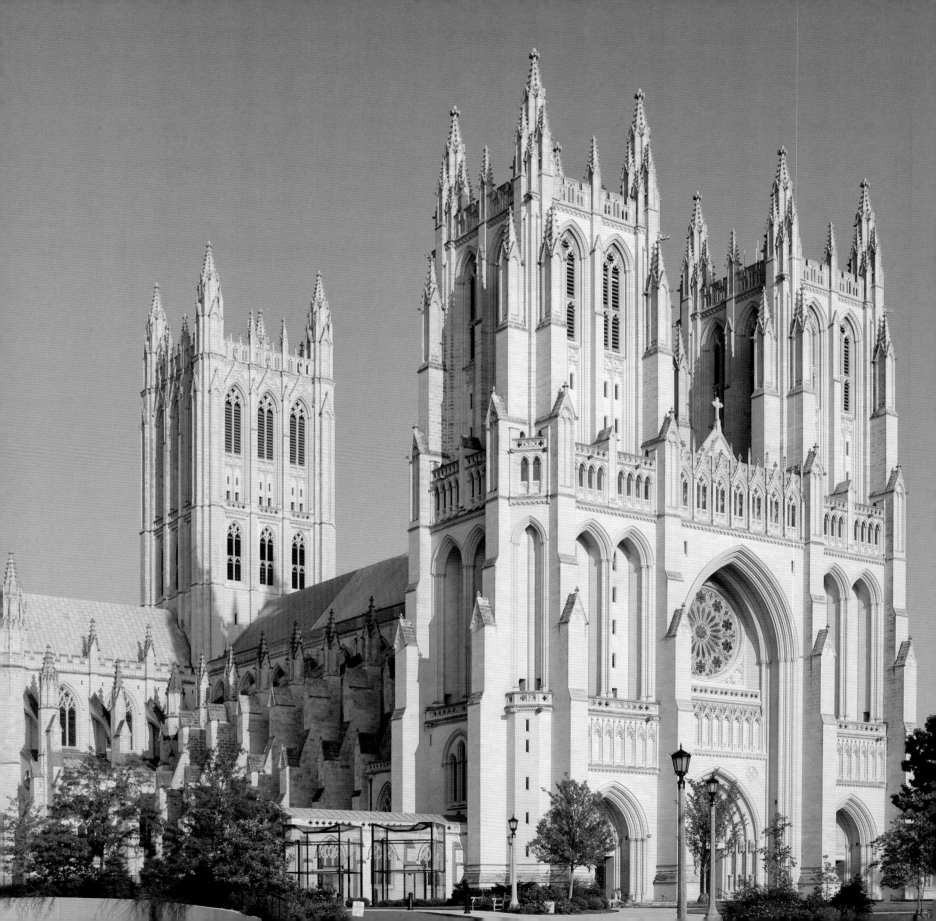

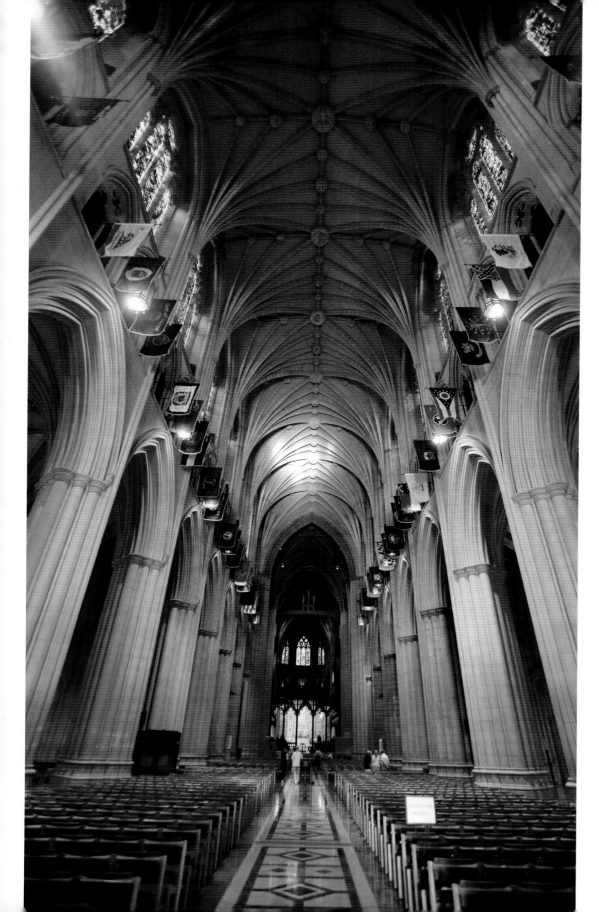

A "great church for national purposes" was always intended in Pierre Charles L'Enfant's master plan for Washington, DC, but it took until 1907 for the foundation stone to be laid. The Cathedral Church of St. Peter and St. Paul, commonly known as Washington National Cathedral, is the sixth-largest in the world and took 83 years, to the day, to complete. It is built in the English Gothic style but has some remarkable 20th-century touches. A stained-glass window commemorating the flight of *Apollo 11* incorporates a piece of actual moon rock.

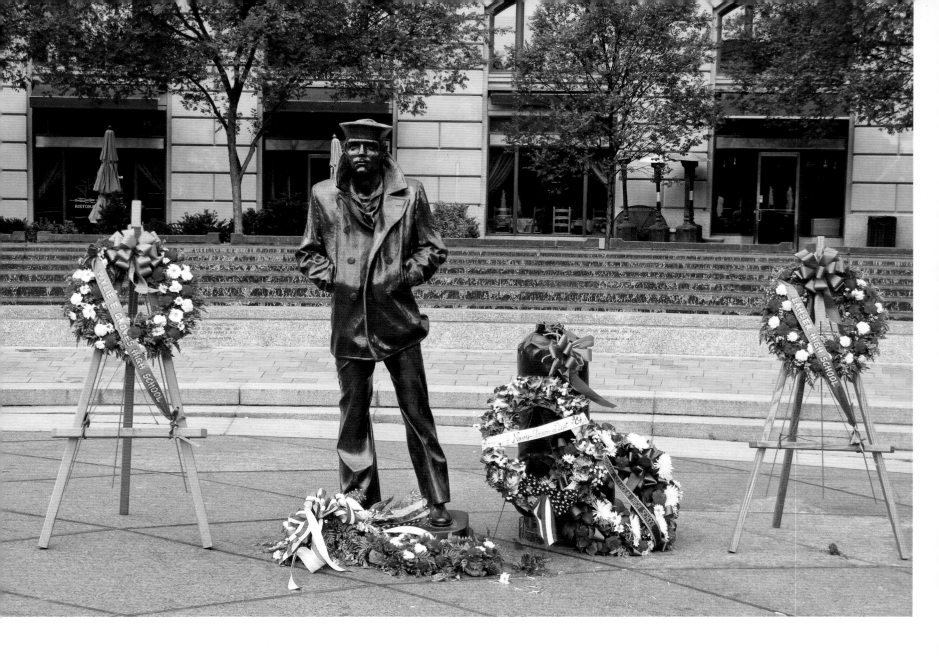

The Lone Sailor, part of the United States Navy Memorial unveiled in 1987, represents past, present and future bluejackets. The bronze statue was cast using artifacts from eight U.S. Navy ships.

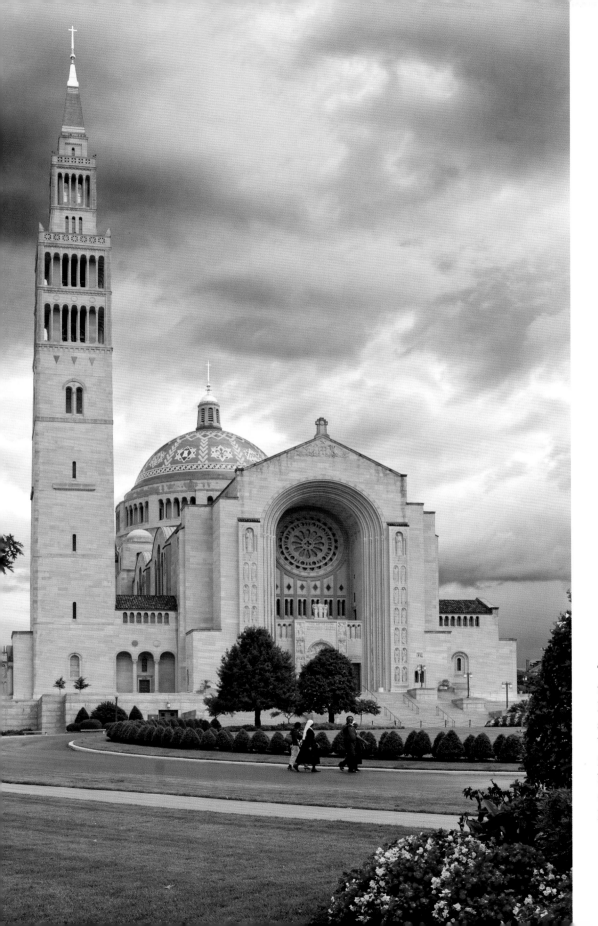

The Basilica of the National Shrine of the Immaculate Conception is the largest Roman Catholic church in North America and the tallest habitable building in Washington. Work on the basilica began in 1920, and it was dedicated in 1959. The basilica holds the world's largest collection of contemporary ecclesiastical art and is known for its brilliant mosaics.

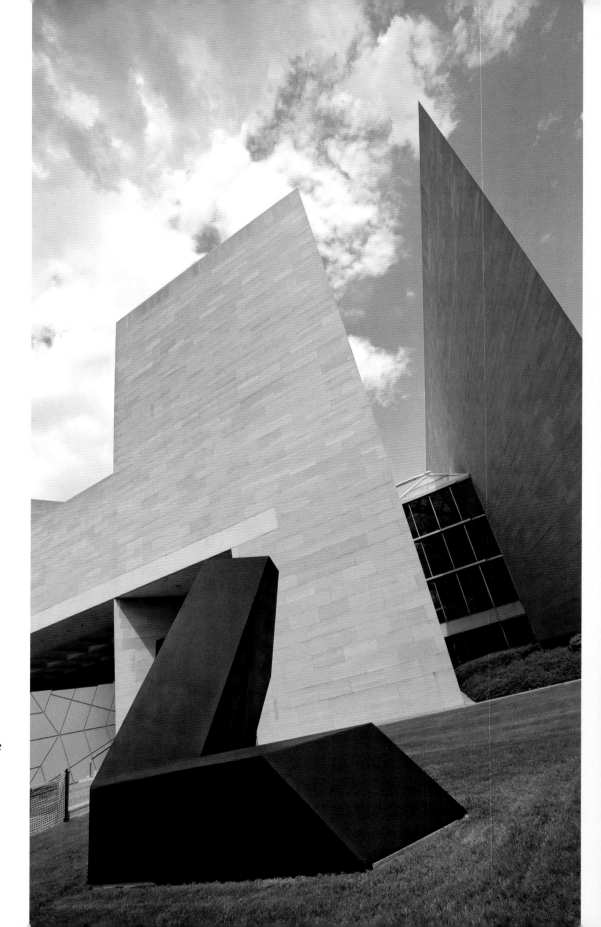

The East Building of the National Gallery
of Art holds mostly modern works, while
the domed West Building includes works
from the medieval period through to the late
19th century. Among the world's foremost
museums, the National Gallery of Art has
a rotating collection of more than one
hundred thousand works.

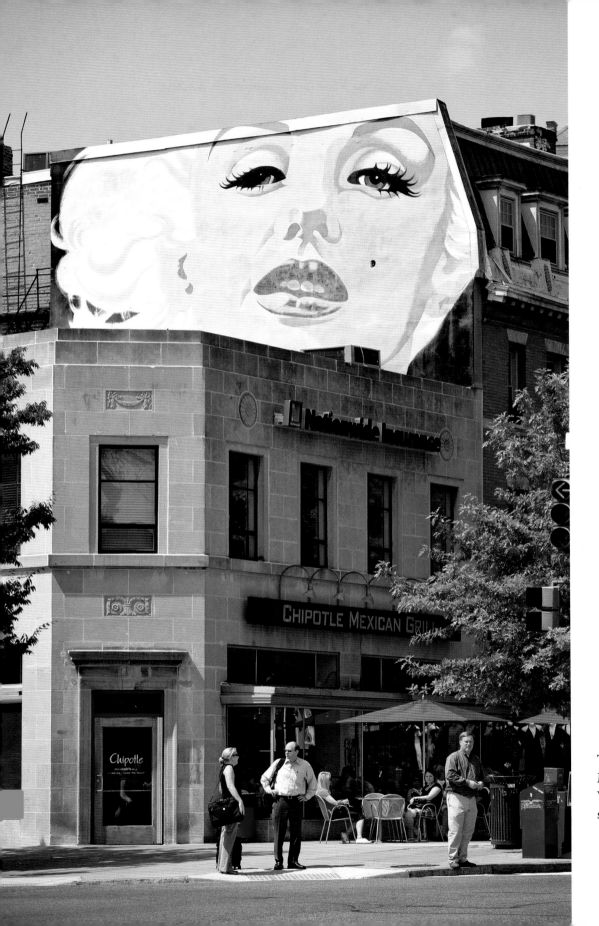

This Connecticut Avenue mural of actress Marilyn Monroe welcomes people to Woodley Park, one of Washington's most sought-after neighborhoods.

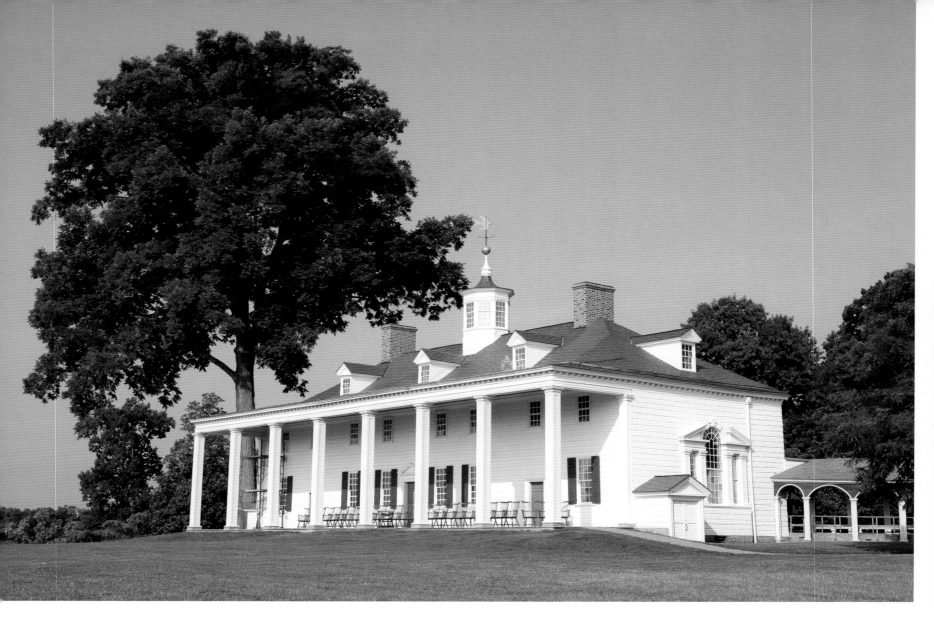

George Washington's plantation, Mount Vernon, dating back to a land grant received by his great-grandfather in 1674, is only 16 miles south of the capital. Today, more than a million tourists annually visit the 18th-century mansion, as well as its plantation outbuildings, family tomb, gardens and farmland.

OPPOSITE PAGE: Headquarters of the Department of Defense, the Pentagon has three times the floor space of the Empire State Building. The five-sided building was constructed in the early years of the Second World War, in response to the War Department's serious shortage of office space, and consolidated 17 buildings. The Pentagon, with 23,000 employees, has 17.5 miles of corridors and occupies 3.8 million square feet.

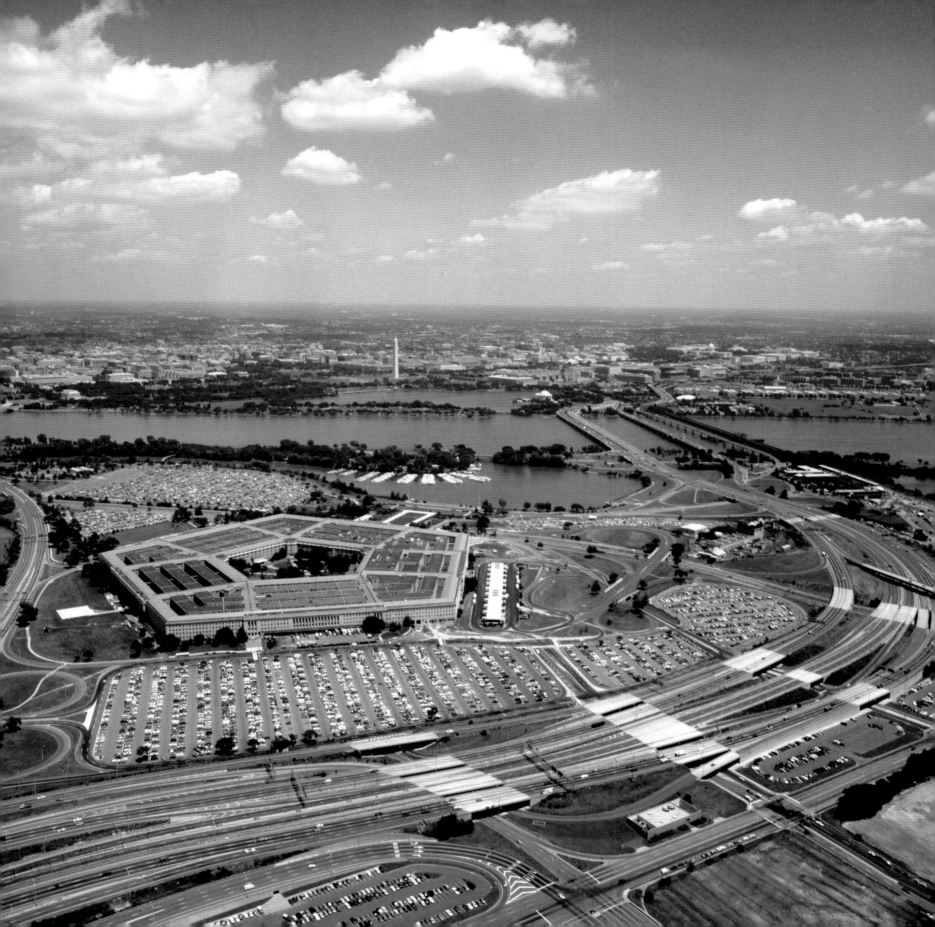

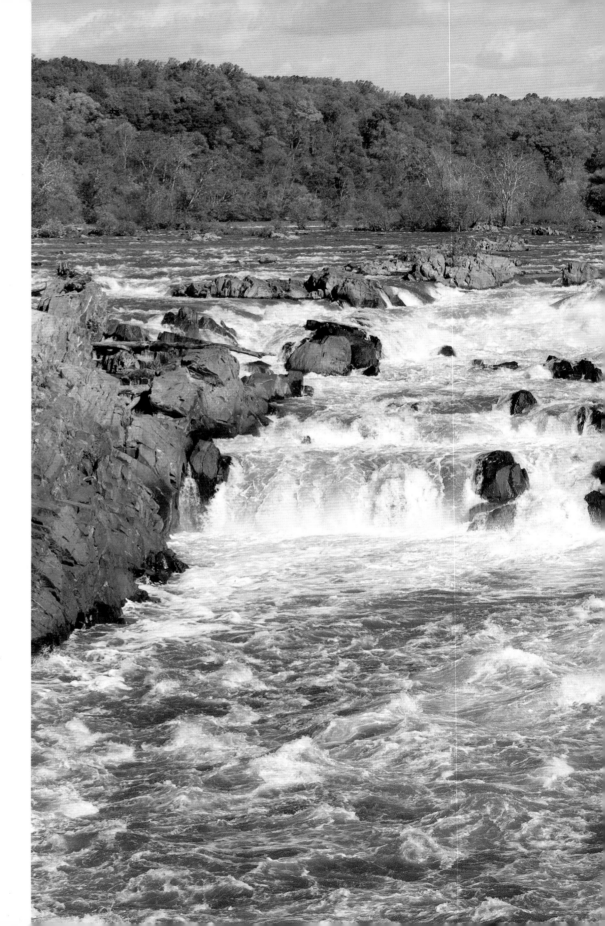

The village of Great Falls, Virginia, is a bedroom community of Washington, DC. At Great Falls Park, the Potomac drops nearly 80 feet in less than a mile. The area is a popular spot for hiking, rock climbing and whitewater rafting.

PREVIOUS PAGE: The Chincoteague National Wildlife Refuge in Virginia and the Assateague State Park in Maryland make up Assateague Island, 37 miles of pristine beaches and wetlands known for their wild horse populations and Assateague Lighthouse.

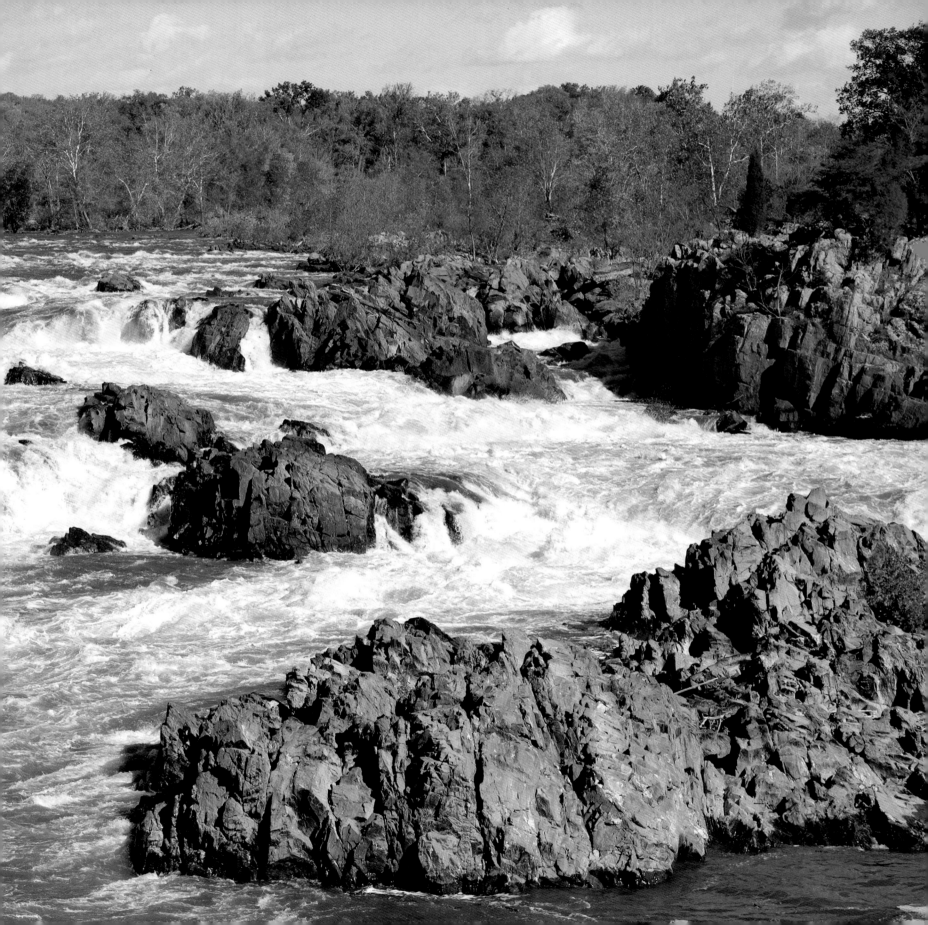

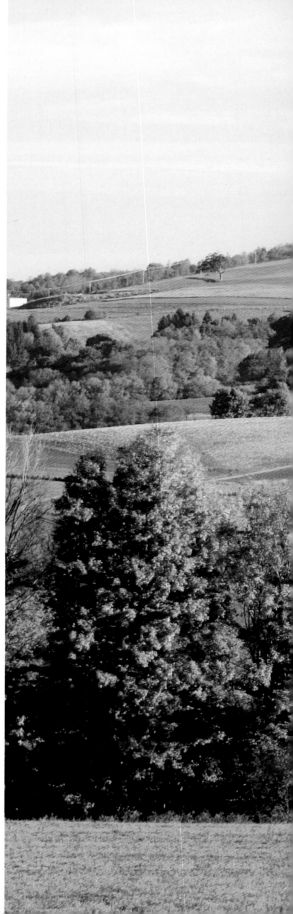

Washington, District of Columbia, has an area of only 68.3 square miles, and of that more than 10 percent is water. Many visitors to the capital spend some time in the neighboring states. Western Maryland boasts a very rural and idyllic landscape that is popular with tourists looking to escape the busy city.

RIGHT: The rolling Appalachian Mountains run through Western Maryland. Many large- and small-scale farming operations surround the numerous national parks in this area.

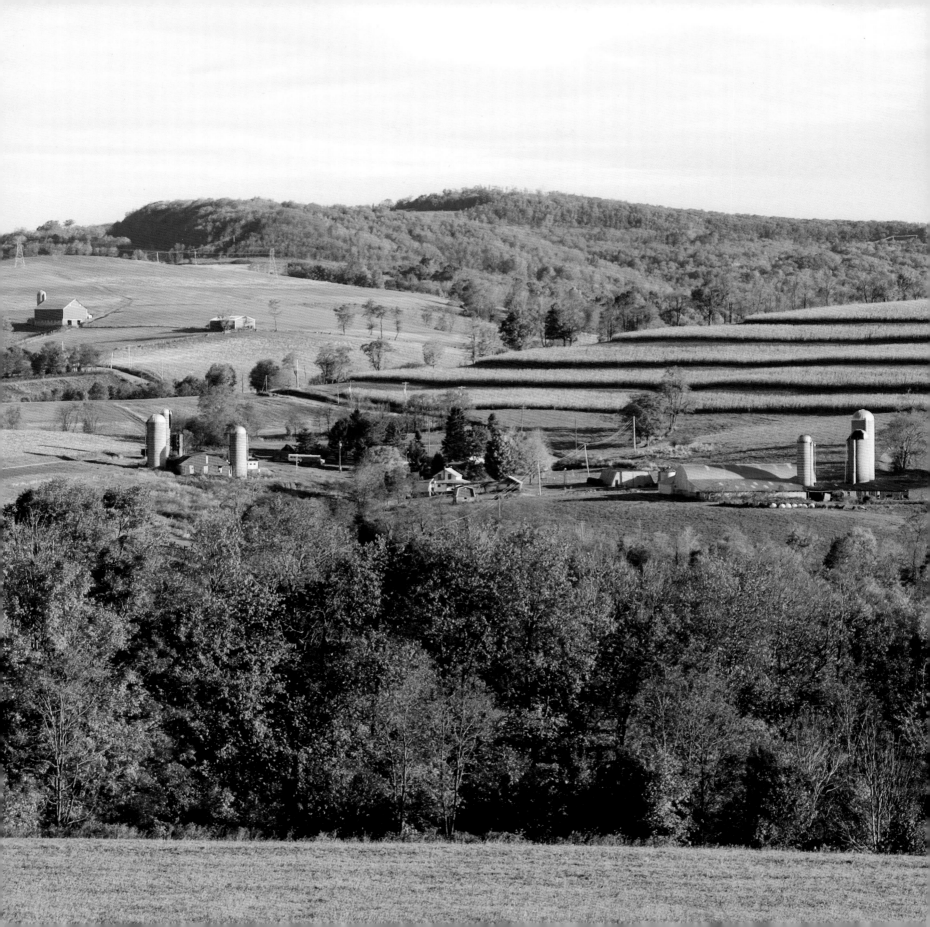

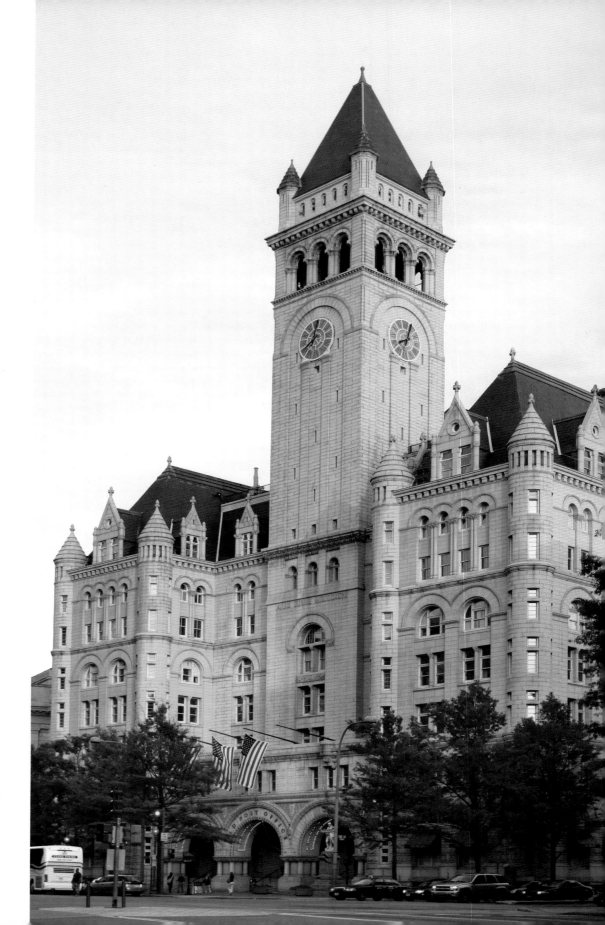

Completed in 1899, the steel and granite Post Office Pavilion – nicknamed Old Tooth – was the city's first skyscraper. Long threatened with demolition, it has been restored and revitalized and today includes a food court, shops and government agencies.

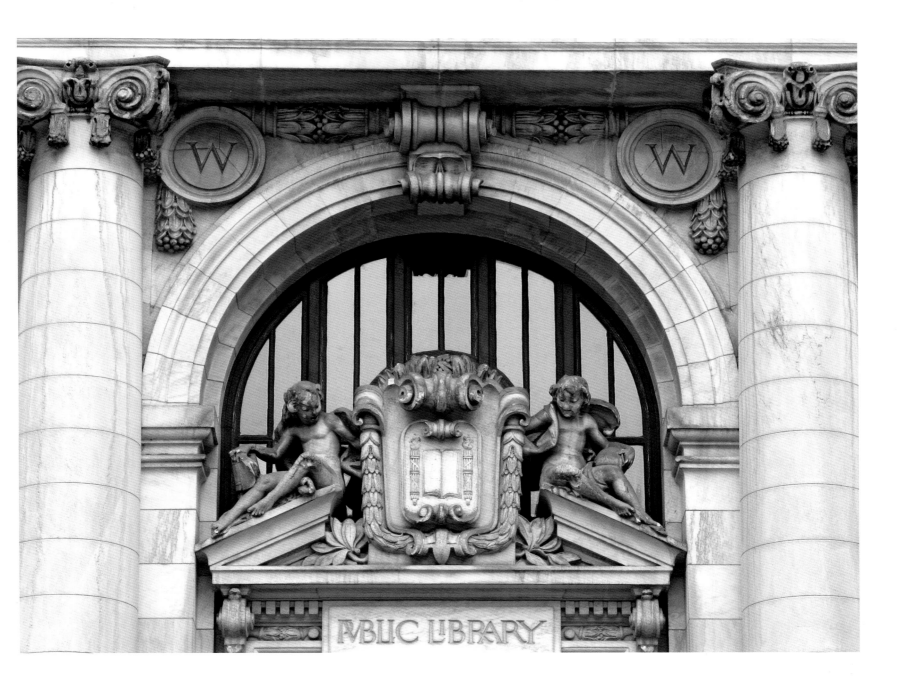

The Historical Society of Washington, DC, is now housed in what was the City Museum and, originally, the District of Columbia Public Library, an exquisite Beaux Arts edifice built by Andrew Carnegie and dedicated in 1903.

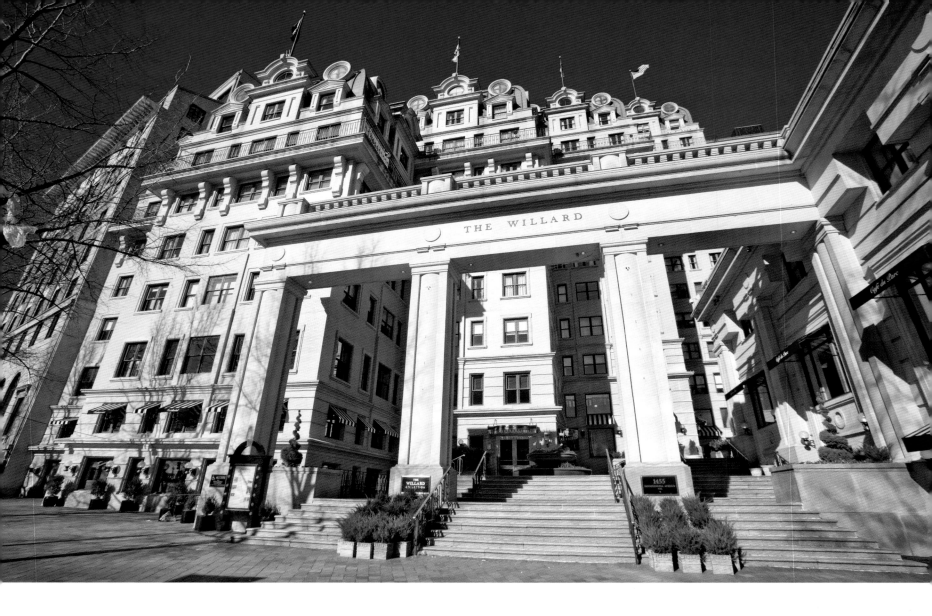

The Willard InterContinental Hotel on Pennsylvania Avenue is only two blocks from the White House. The hotel has accommodated guests since the early 19th century, among them President Lincoln, Charles Dickens, Harry Houdini and Martin Luther King Jr. (who wrote his "I Have a Dream" speech in a room here).

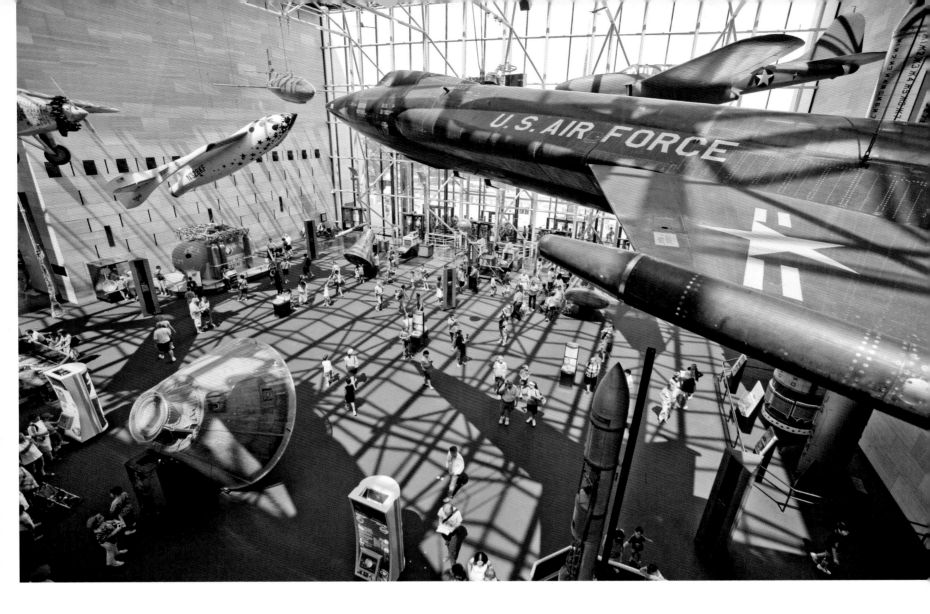

The National Air and Space Museum on the National Mall chronicles the history of flight from the Wright Brothers to the space shuttle and beyond. With 50,000 historic air and spacecraft, by far the largest collection in the world, the museum can display only a fraction of its holdings. The Steven F. Udvar-Hazy Center on the grounds of Washington Dulles International Airport provides a second showcase for the collection.

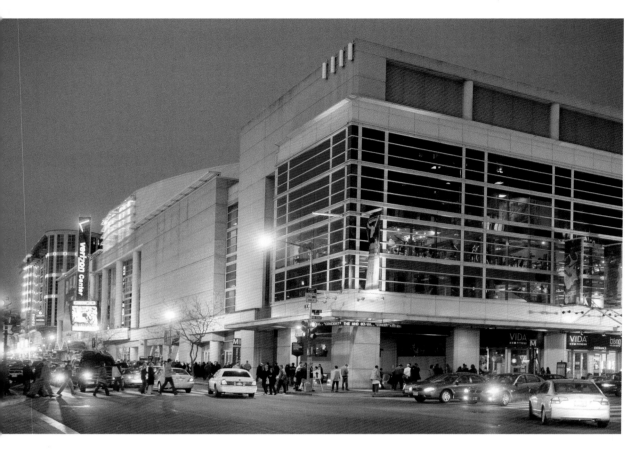

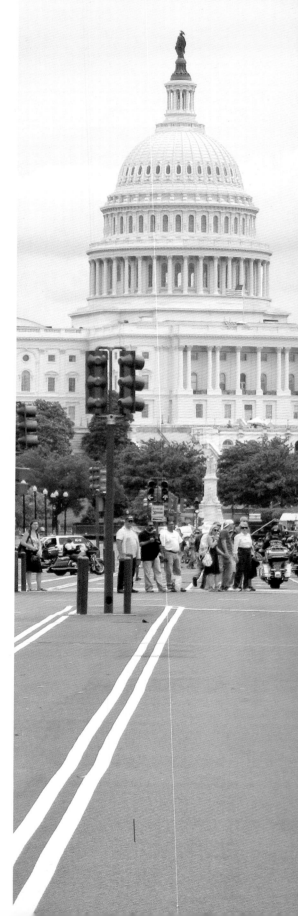

ABOVE: The Verizon Center, home of the Washington Wizards, the Washington Capitals and the Washington Mystics, was completed in 1997 at a cost of $200 million. Its presence in the heart of Chinatown in downtown Washington has sparked a massive redevelopment effort.

RIGHT: Rolling Thunder motorcyclists converge on the Mall in their annual Ride for Freedom. The major function of the group is to publicize prisoner of war–missing in action issues, and its members are committed to helping American veterans from all wars.

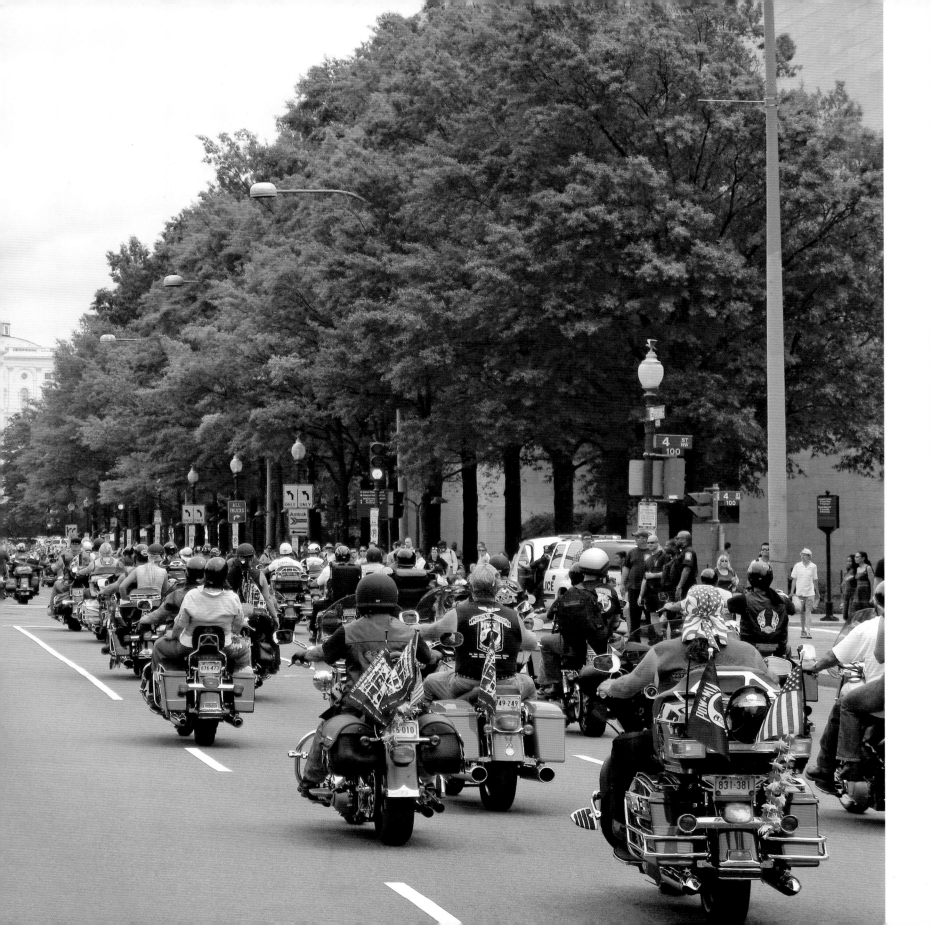

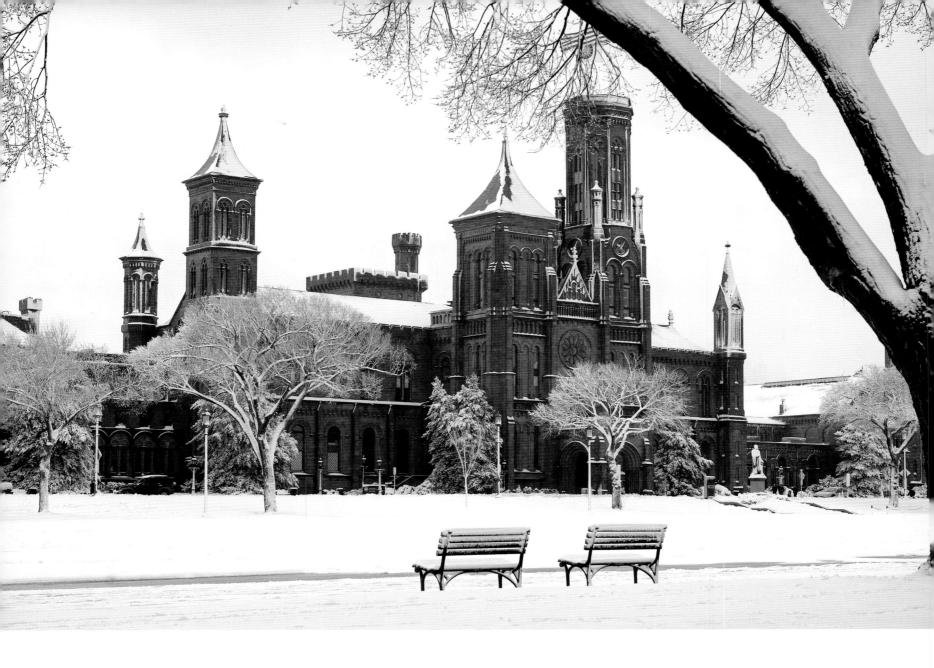

Known as the "Castle," this Norman-style red-sandstone building, dating from 1855, is the oldest on the Mall and the symbolic head of the Smithsonian Institution, which comprises 19 museums, nine research centers and a zoological park. More than 24 million people visit these museums annually, and the Smithsonian's collection of over 137 million artifacts continues to grow.

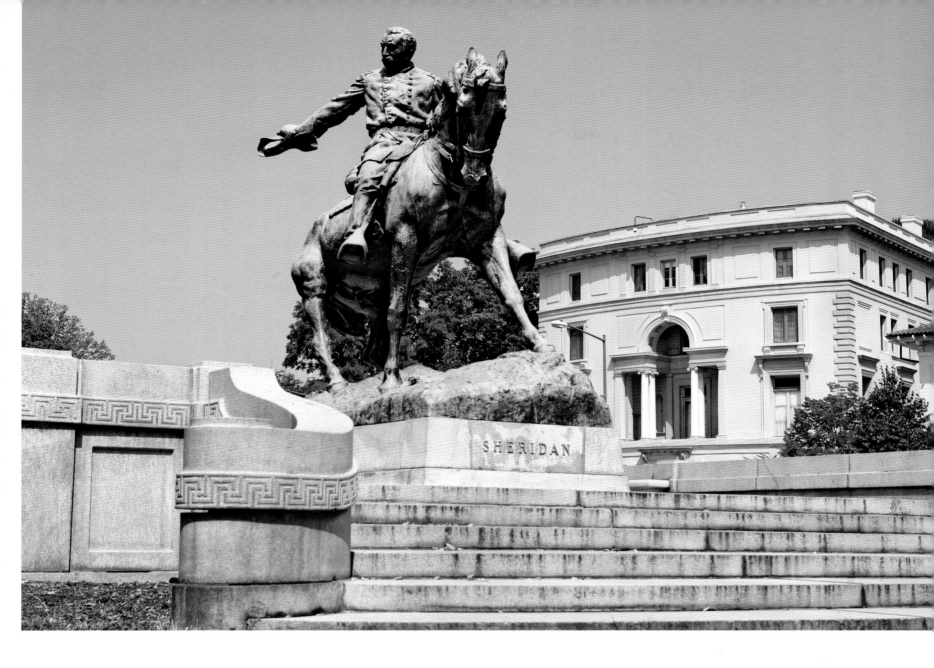

Sheridan Circle, a traffic circle in the heart of Washington's Embassy District, is named for the Civil War general Philip Sheridan, whose equestrian statue sits in the center of the ring.

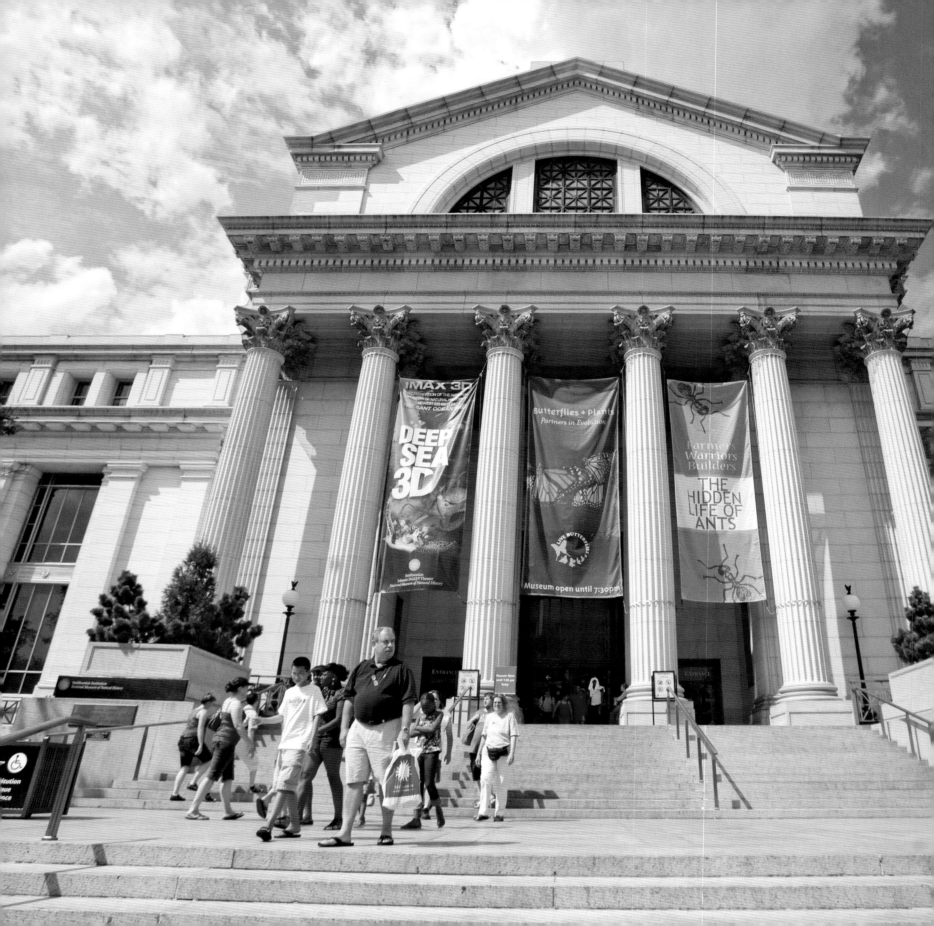

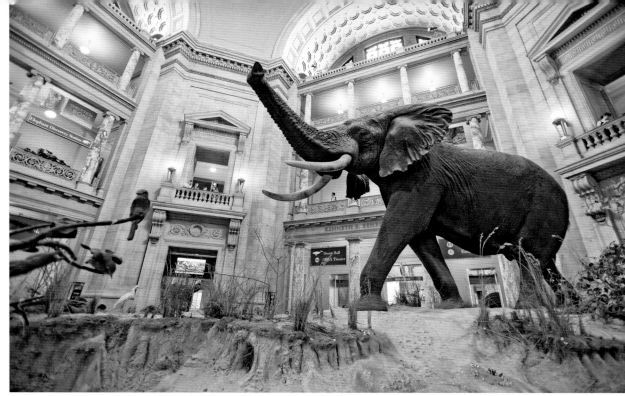

ABOVE: Children often know the Smithsonian National Museum of Natural History by another name – the "Elephant Museum." This massive, eight-ton African elephant was 50 years old when it died in 1955. Its size was so remarkable that the hunter decided to donate it to the Smithsonian. Ever since, it has been proudly displayed beneath the rotunda.

LEFT: The Smithsonian National Museum of Natural History opened the doors to this massive complex in 1910. Since that time, it has developed into a treasure trove containing everything from the Hope Diamond, to half a million dinosaur fossils, to a 24-foot-long giant squid.

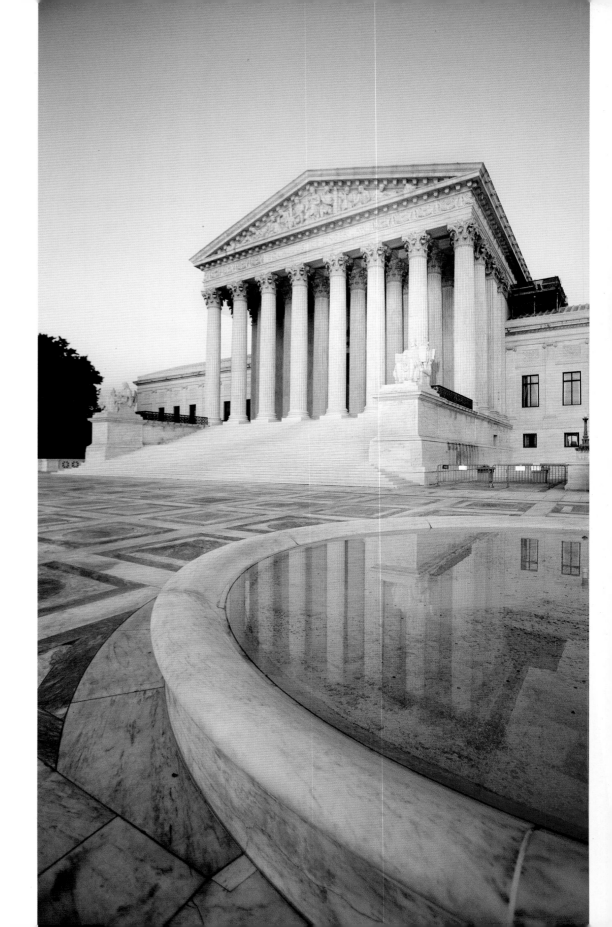

Although in existence since 1789, the Supreme Court, charged with "judicial review" of all branches of government and government officials, did not have its own building until 1935.

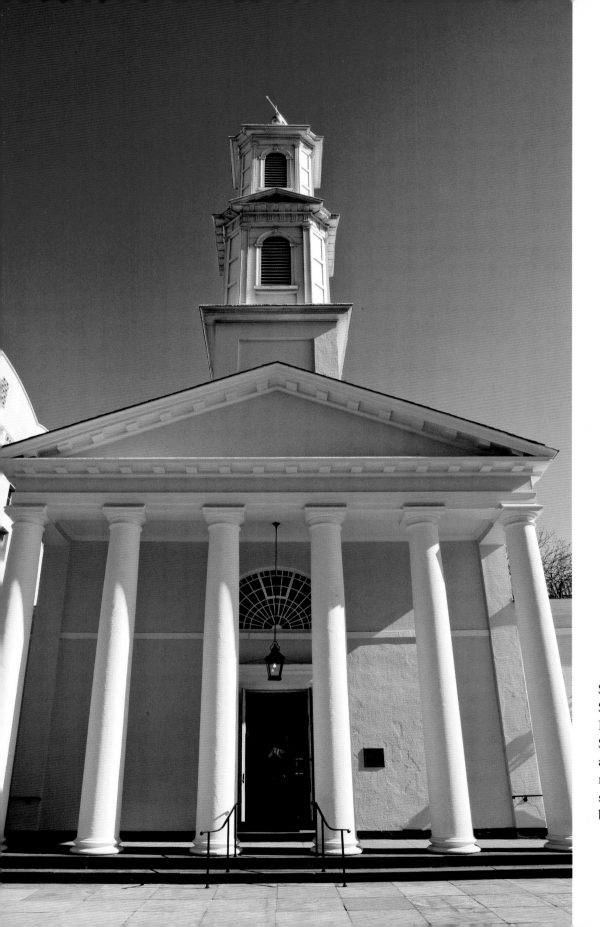

St. John's Episcopal Church on Lafayette Square, known as the "Church of the Presidents," first opened its doors in 1816. Since that year, every president has attended at least one service there – with Pew 54 always reserved for the head of state. Paul Revere's son Joseph cast the church's 1,000-pound bell in 1822.

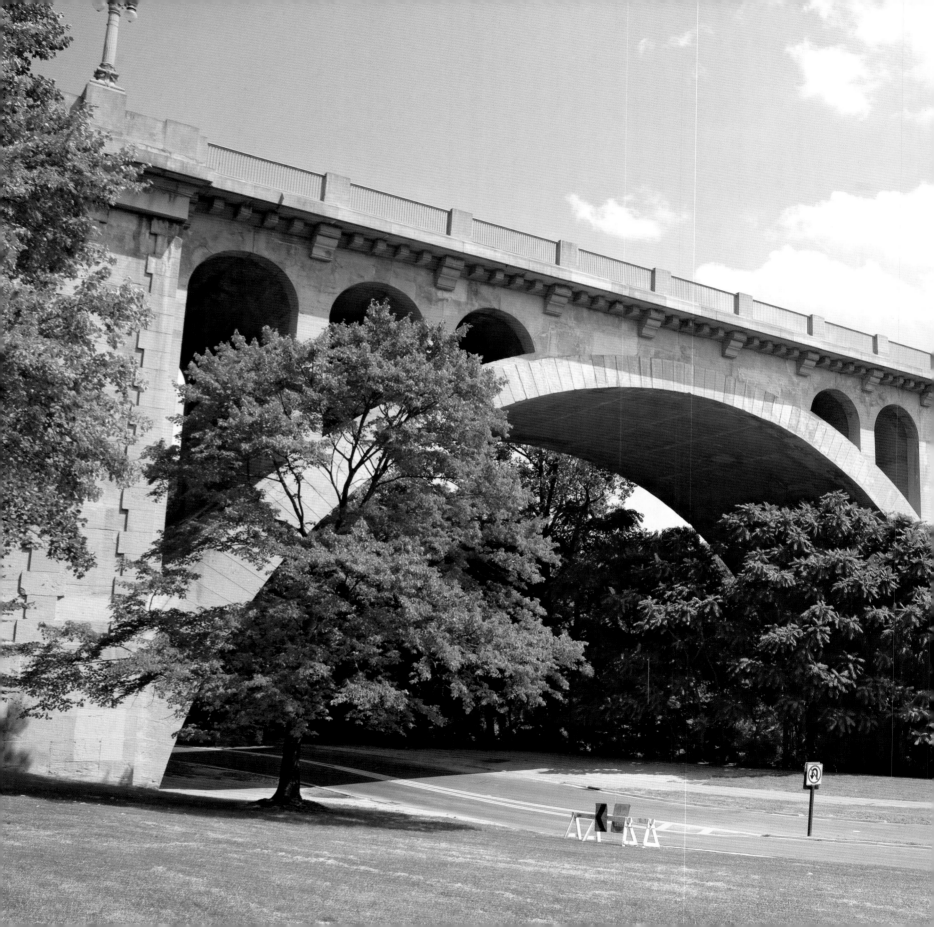

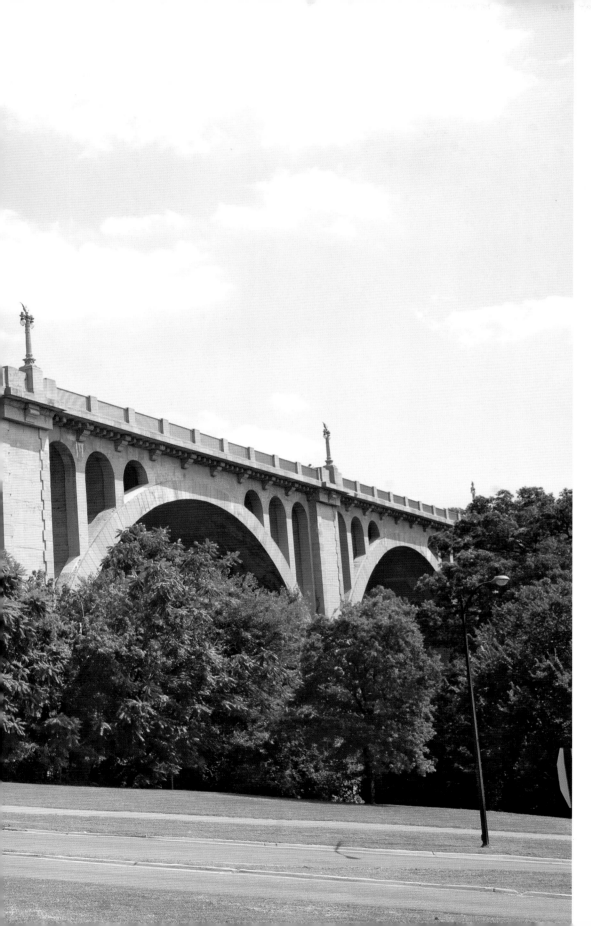

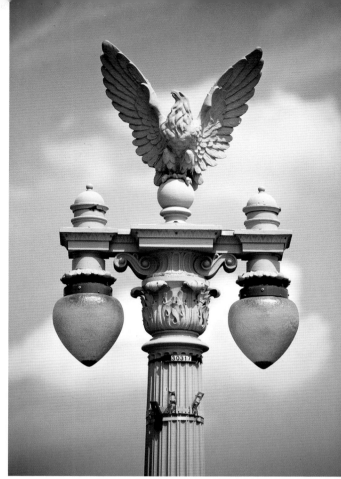

The Taft Bridge, also known as the Connecticut Avenue Bridge, carries traffic over Rock Creek and connects the Washington neighborhoods of Woodley Park and Kalorama. The largest unreinforced concrete bridge in the world, it boasts lion sculptures and eagle-ornamented lampposts (above).

RIGHT: Thomas Circle is a large traffic circle in northwest Washington. The large statue in the center, of General George Henry Thomas on horseback, was erected in 1879. Seen directly across the circle is the National City Christian Church, completed in 1930.

BELOW: The Treasury Building, designed in the 1830s by Robert Mills, the architect of the Washington Monument, is the largest Greek Revival structure in Washington. Once used to store currency, the building now holds the offices of the U.S. Department of the Treasury.

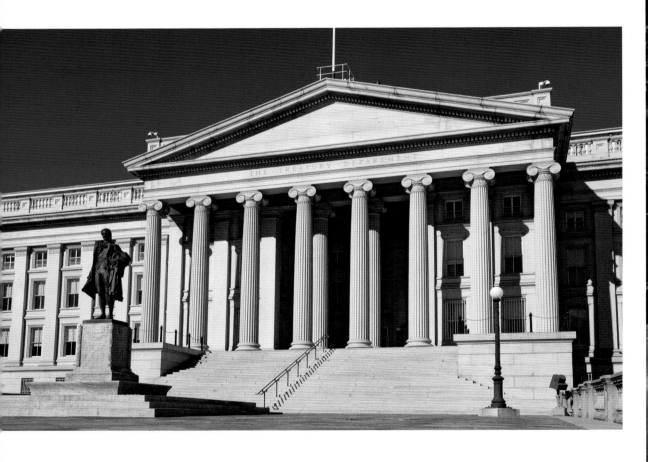

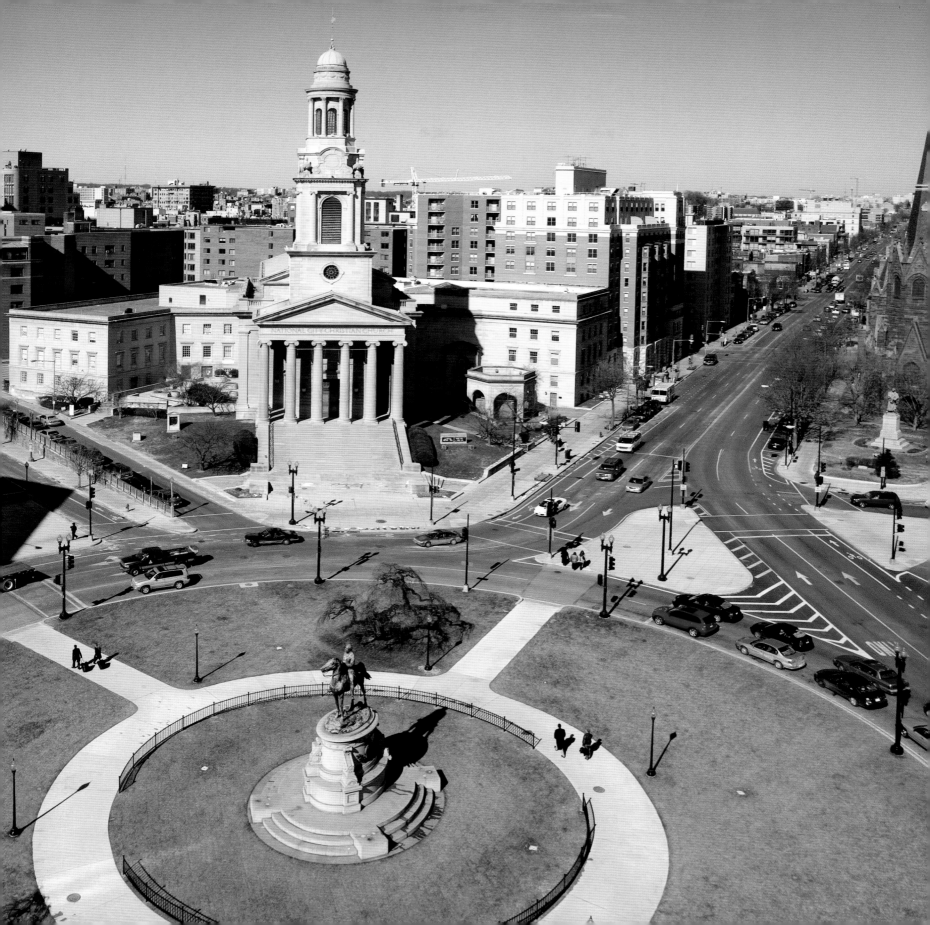

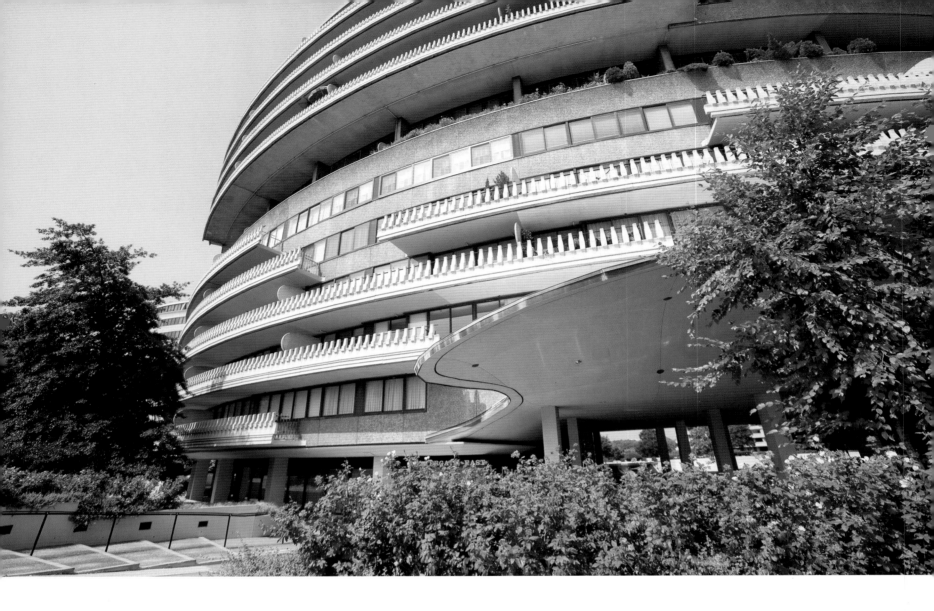

The Watergate Complex, a group of five large buildings next to the Kennedy Center for the Performing Arts, is famous as the site of the 1970s scandal that led to the resignation of President Richard Nixon.

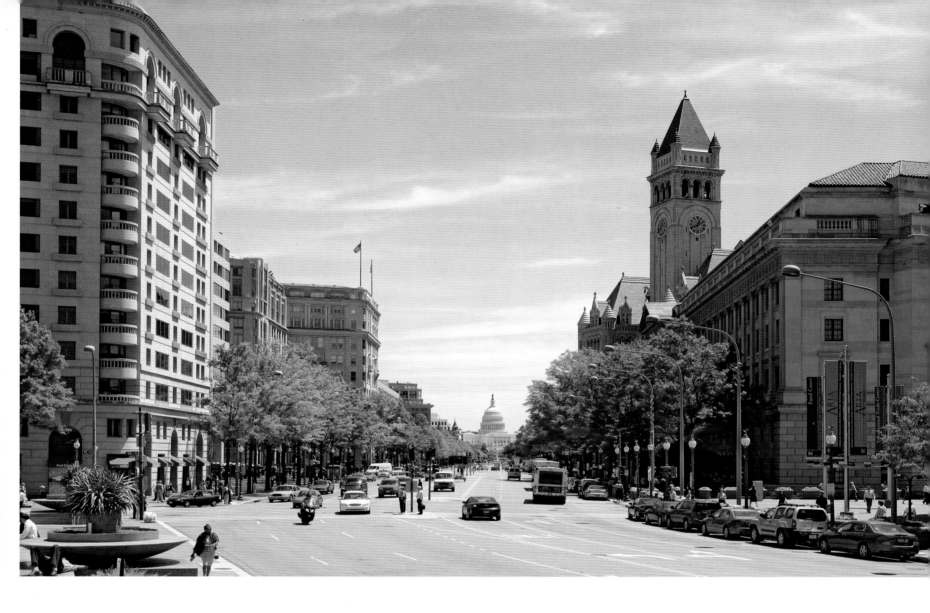

Pennsylvania Avenue, often referred to as "America's Main Street," was laid out by Pierre Charles L'Enfant and joins the White House with the U.S. Capitol. An important commuter route, Pennsylvania Avenue has also witnessed the procession of most presidents after they take the oath of office.

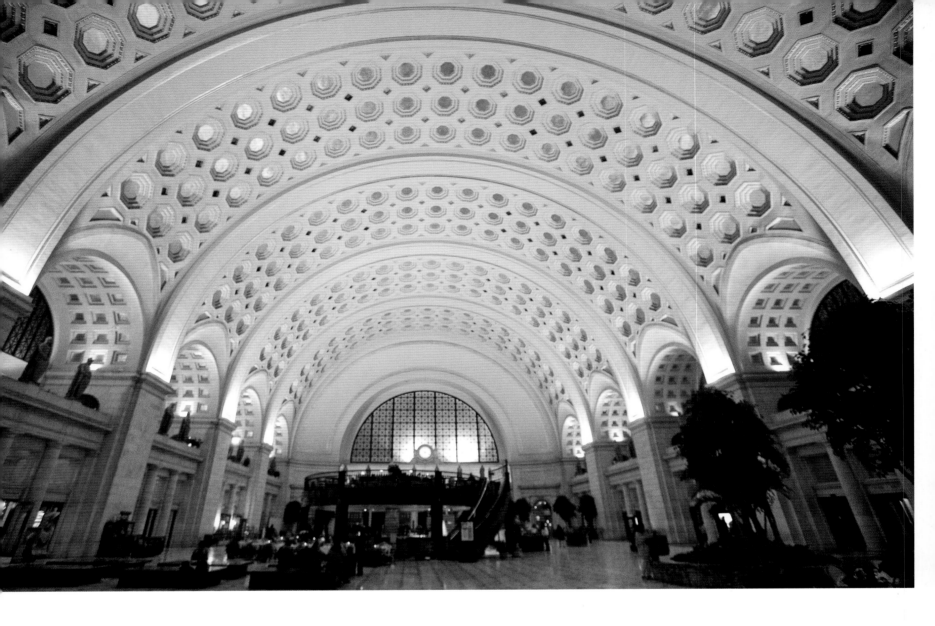

Union Station was created with grandeur in mind. Seventy pounds of 22-karat gold leaf were used to adorn its barrel-vaulted ceilings, and along its endless halls one could once find everything from the presidential suite to Turkish baths. The station's white granite exterior had a major influence on Washington's monumental architecture.

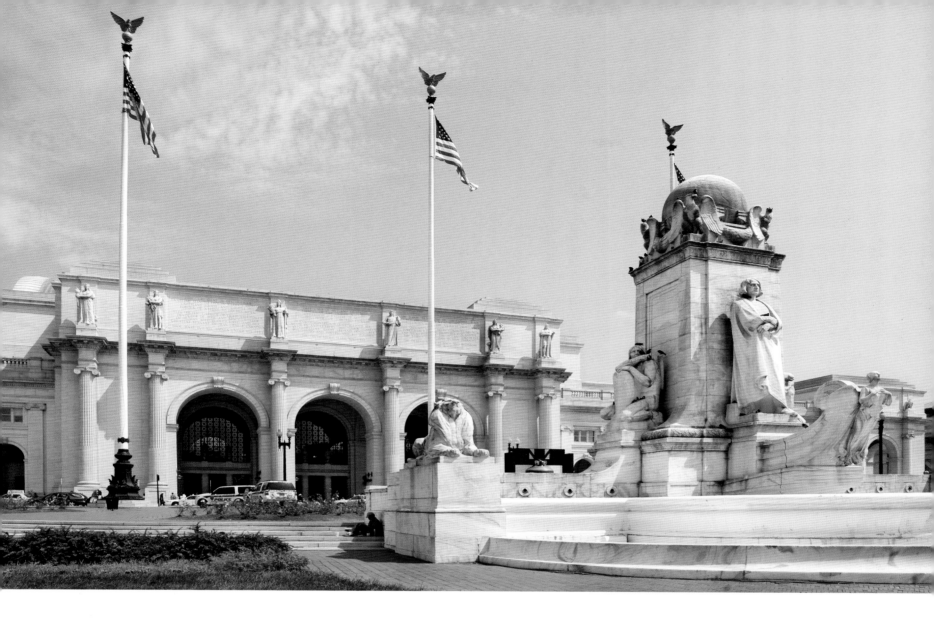

The largest train station in the world at the time it opened – October 1907 – is only a short walk from the Capitol. Union Station still functions as a terminal, but many of the 32 million people who visit it each year come to admire the Beaux Arts architectural style or enjoy the many shops and restaurants.

One of the most poignant sights in Washington is the Vietnam Veterans Memorial, erected in 1982. Two black granite walls, inscribed with the names of the men and women who died in America's longest war, stretch into a V, one side pointing at the Washington Monument, the other at the Lincoln Memorial.

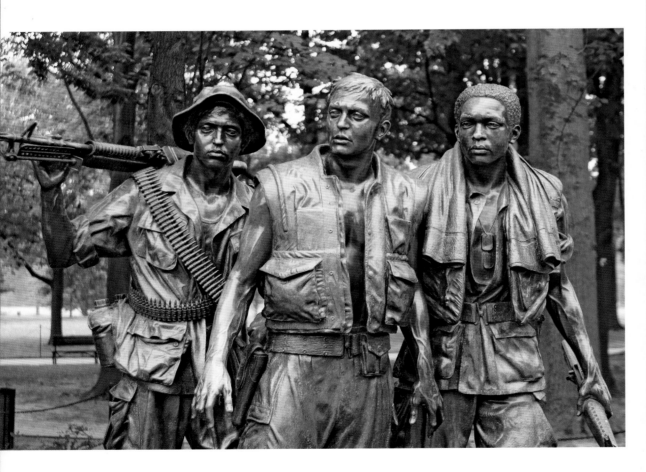

The Three Soldiers is a sculpture that, along with the Vietnam Women's Memorial, completes the Vietnam memorial complex. This bronze was unveiled on Veterans Day, 1984.

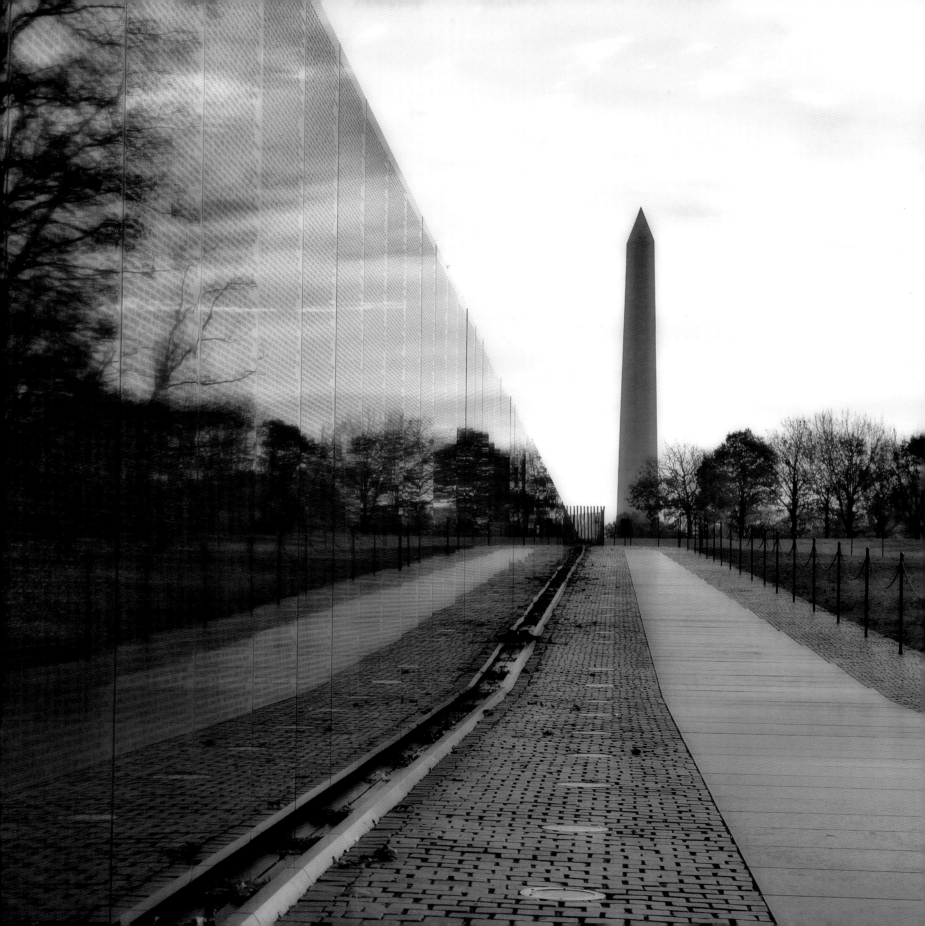

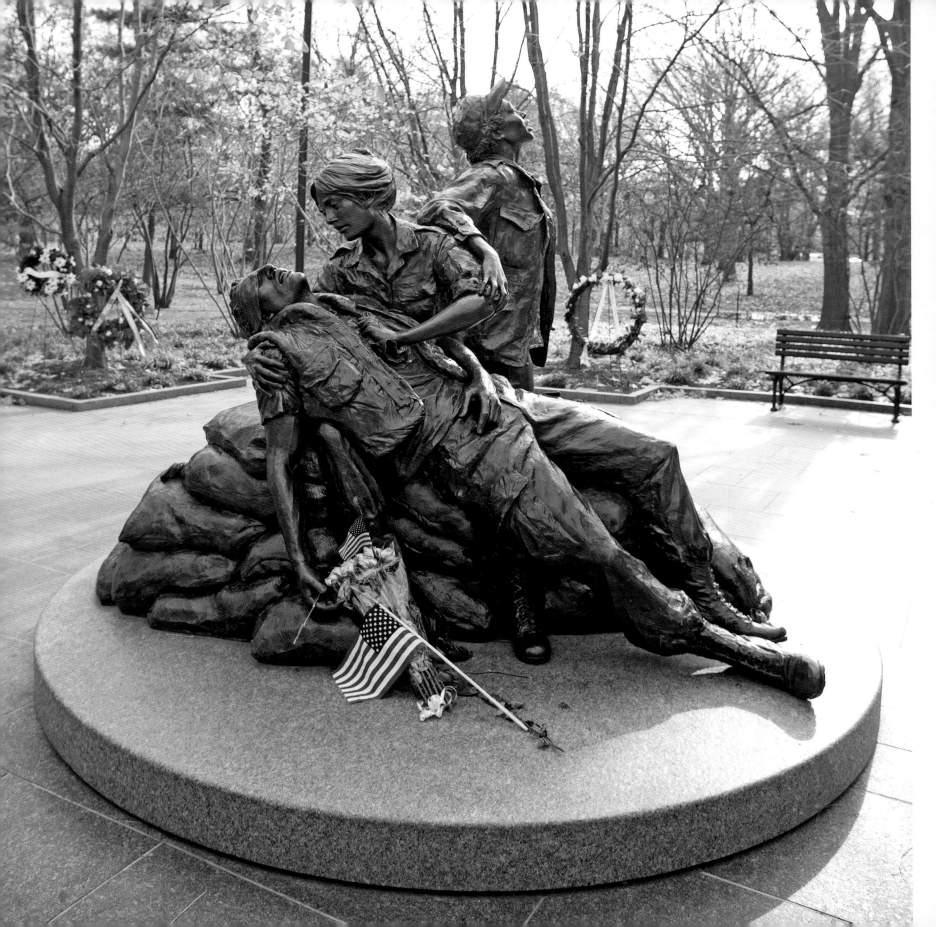

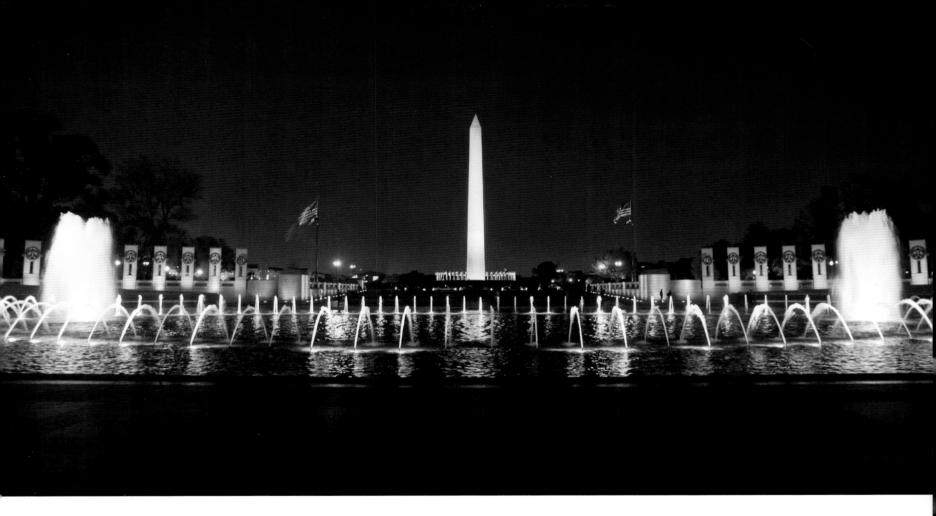

The National World War Two Memorial in Washington was dedicated in 2004 before a crowd of 150,000 people. Fifty-six 17-foot-tall granite pillars representing the states and territories flank a central plaza and the Rainbow Pool. The 7.5-acre memorial also includes fountains and a wall of 4,000 gold stars, each representing 100 servicemen who died in the conflict.

OPPOSITE PAGE: Protest against the lack of recognition of the 265,000 women who volunteered to serve in the Vietnam War led to the unveiling of the Vietnam Women's Memorial in 1993.

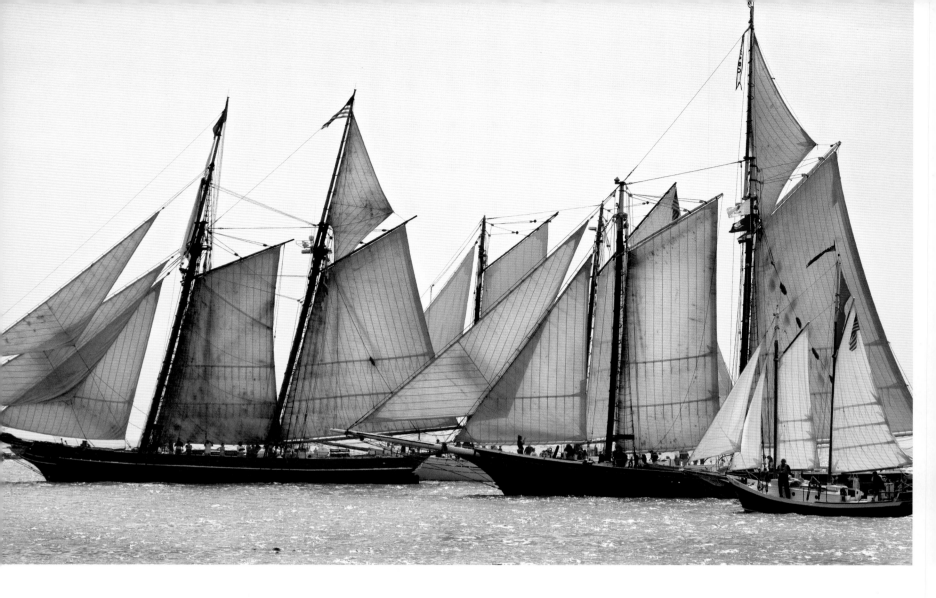

These large wooden schooners are sailing in one of numerous boating festivals held each year on Chesapeake Bay, the largest estuary in the United States. From Washington, the Potomac River empties into Chesapeake Bay.

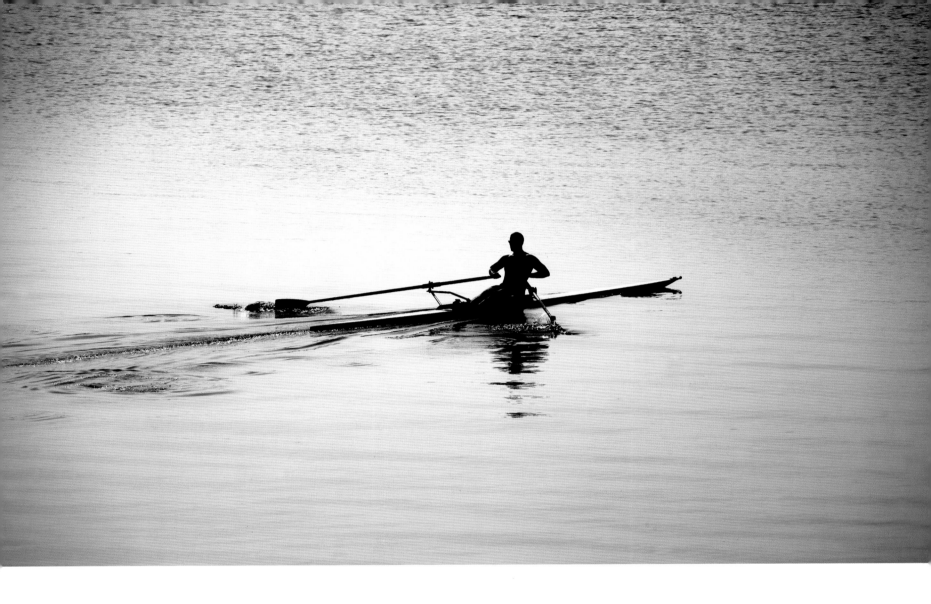

Although more than five million people live in the watershed of the Potomac River, recreational boating, rowing and other activities continue to flourish.

Although the idea of a tribute to the life and work of George Washington first arose at the Continental Congress of 1783, the cornerstone of what we now know as the Washington Monument wasn't laid until July 4, 1848. Even then, the monument's construction repeatedly stalled for nearly 40 years, interrupted by the Civil War and a lack of funds.

FOLLOWING PAGE: In this stunning aerial view of Washington, DC, Pierre Charles L'Enfant's 1791 master plan for the city becomes clear. The street layout incorporates a basic grid system, and grand avenues radiate from the Capitol.

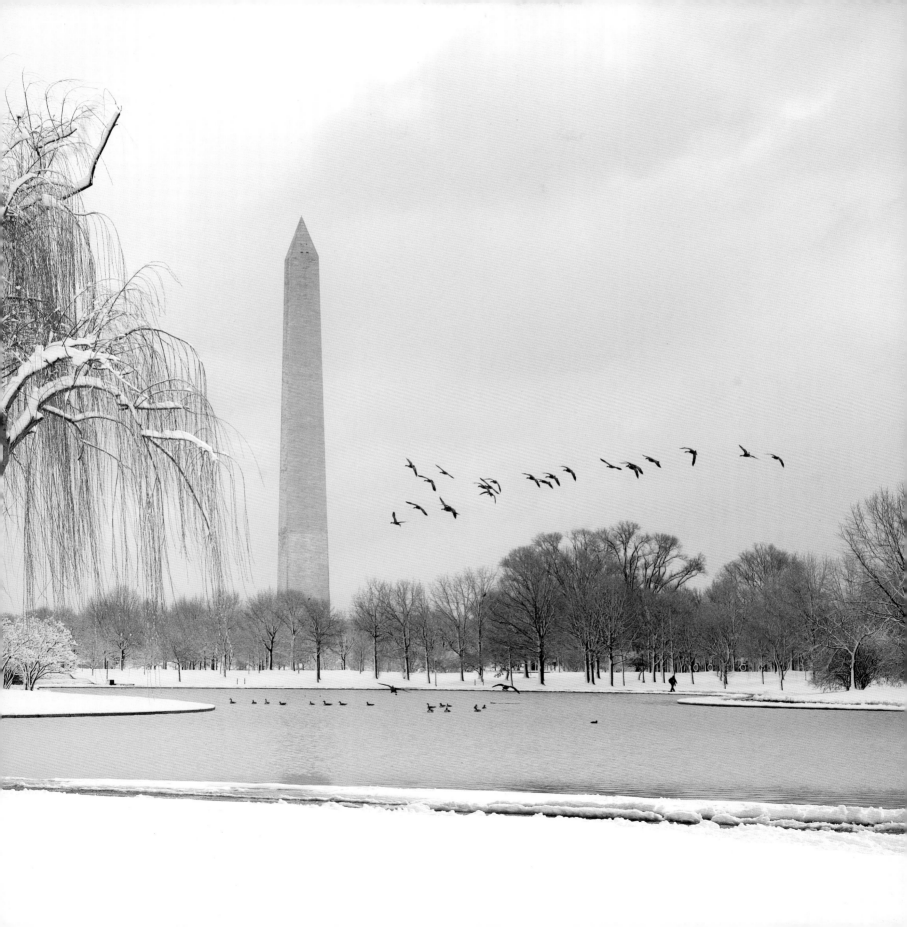

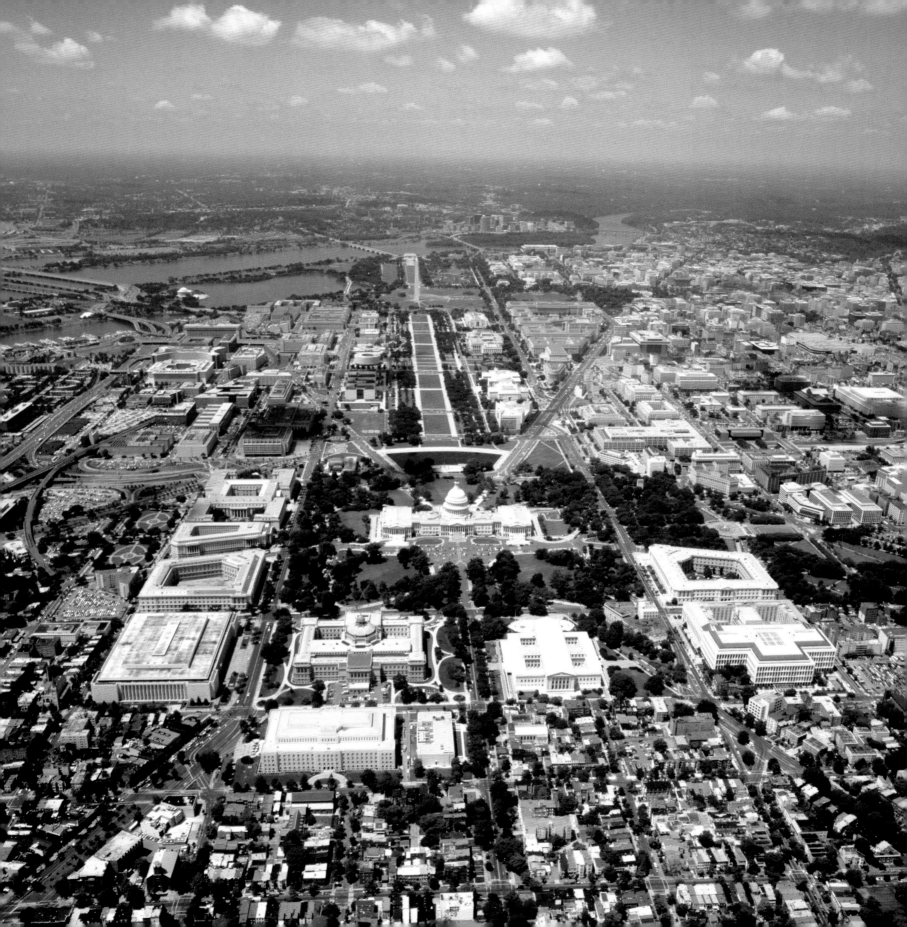